Published by Akashic Books
©2011 Dwayne Booth

ISBN-13: 978-1-61775-014-4
Library of Congress Control Number: 2010939103

First printing
Printed in China

Akashic Books
PO Box 1456
New York, NY 10009
info@akashicbooks.com
www.akashicbooks.com

For Jeff,
who, in my earliest memory, is running ahead of me in the blinding sunlight through the
tall, yellow grass in New Jersey, laughing his head off, not wanting to get caught and not
wanting to get away, making me a path to feel fast in

And special thanks to Robert Scheer and Zuade Kaufman of Truthdig
for providing the horn for my bull

TABLE OF CONTENTS

MR. FISH IN 2003 DECIDING THAT HE WANTS TO BE A DISEASE WHEN HE GROWS UP BECAUSE HE KNOWS
THAT THE WORLD WILL NEVER BE SAVED BY THE MIGHT OF A SUPERMAN OR THE WILL OF A JESUS OR
THE INGENUITY OF AN APPLE COMPUTER OR THE PREJUDICIAL TRAJECTORY OF A BULLET, BUT RATHER
BY THE STEADY INTRODUCTION OF UNPOPULAR AND CRUDE AND PERVERTED IDEAS CAPABLE OF ACTIVAT-
ING, LIKE AN ANTIBIOTIC, THE MORAL IMMUNE SYSTEM OF THE PUBLIC WHO WILL THEN SURVIVE OR NOT.

MR. FISH

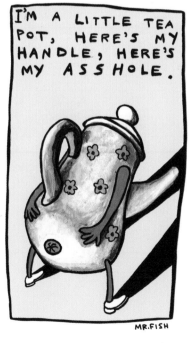

MR. FISH

IN ALL LIKELIHOOD HISTORY WILL BEAR OUT
GEORGE W. BUSH'S SELF-MADE COMPARISON
TO WINSTON CHURCHILL AS A JUSTIFICATION
FOR INVADING IRAQ.

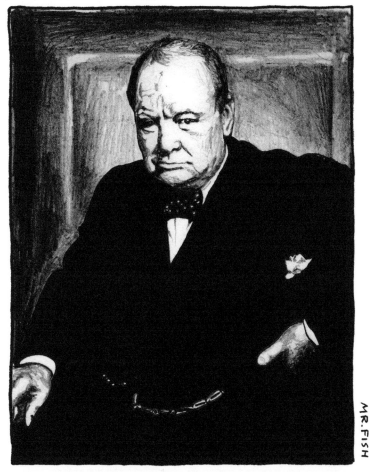

MR. FISH

"I DO NOT AGREE THAT THE DOG IN A MANGER
HAS THE FINAL RIGHT TO THE MANGER EVEN THOUGH
HE MAY HAVE LAIN THERE FOR A VERY LONG
TIME. I DO NOT ADMIT THAT RIGHT. I DO NOT
ADMIT FOR INSTANCE THAT A GREAT WRONG
HAS BEEN DONE TO THE RED INDIANS OF AMERICA
OR THE BLACK PEOPLE OF AUSTRALIA. I DO NOT
ADMIT THAT A WRONG HAS BEEN DONE TO THESE
PEOPLE BY THE FACT THAT A STRONGER RACE,
A HIGHER GRADE RACE, A MORE WORLDLY-WISE
RACE TO PUT IT THAT WAY, HAS COME IN AND
TAKEN THEIR PLACE." —WINSTON CHURCHILL, 1937.

Go, Fish. Go!

(an introduction)

Elisabeth Kübler-Ross wrote a book in 1969 called *On Death and Dying*. In it she described how there are five stages of grief that one might expect to experience when facing the end of life. When it became a national best seller, she expanded the concept to include anybody experiencing a catastrophic personal loss, like a drug addict hitting rock bottom or anybody who suddenly finds himself or herself incarcerated or destitute or limbless or celibate or pregnant. Then the concept was expanded further still, to include anybody who has ever been passed over for a promotion at work or anybody whose pet has ever run away or anybody who has ever woken up with beard burns on her uterus and the sound of the First Battalion, Twenty-Third Marine Regiment singing "Thank Heaven for Little Girls" from the shower. Anybody, really, who has been blessed by a normal life and who has easy access to the K shelf in the death-and-dying section of a bookstore.

The five stages of grief, according to Kübler-Ross, are, from first to last: 1) denial, 2) anger, 3) bargaining, 4) depression, and 5) acceptance. Of

course, those stages are now as endemic to how we perceive ourselves as the way we brush our teeth and elect our presidents and seek out validation in self-help books for any emotion that we find we cannot repress effortlessly.

Now, assuming that these are, in fact, legitimate emotional phases that everyone experiences when clobbered by some unforeseen disaster (and not simply just another academic concoction designed to sell books and further promote the bullshit illusion that the inner workings of a human being can be sorted and labeled and cataloged and understood as easily as the innards of a cuckoo clock), I have to figure that these must also be the same stages that a person who attempts to preemptively clobber disaster before being clobbered by it must experience, only in reverse. Somebody who can look up and recognize impending disaster everywhere, as if each potential disaster were a big stinky bison, part of a dispersed herd both polka-dotting the horizon and standing close enough to fog the sheen off our patent leather shoes while munching at the flowers that we planted in celebration of our eternal optimism.

Thusly, just such a person would begin by 1) *accepting* the fact that he lives in the world and has a certain measure of responsibility to help maintain both his own and the world's longevity and well being. Perhaps his motivations are selfish, purely predicated on something as ignoble as self-preservation. No matter, he accepts that he would rather survive in the world than succumb to its hostilities, knowing full well that there are forces and menacing realities that exist contrary to his mission, maybe even in active contempt of it. He accepts that his egotism may not keep him safe, but that it might confuse him sufficiently with just enough narcissism to propel him forward with some self-edifying sense of purpose into a lifetime unlikely to corroborate his self-regard.

Almost immediately 2) *depressed* by his inability to profoundly improve upon the indifferent mediocrity of human existence or to inspire a global collaboration between enlightened men and women capable of challenging the thuggish inhospitality of the world and to ultimately mellow it, he will wonder if his innate desire to help maintain both his own and the world's longevity and well being is a waste of time. Maybe it is even worse than that; specifically, a terminal form of spiritual self-destruction. Perhaps it is a death wish. Like a prisoner confined to a tiny cell, he will question the usefulness of his dreams of freedom, believing that because they are unreal beyond the confines of his sleep and have never known physical expression, they must be nightmares. How else to explain the impossibility of their realization? He

is a stone preoccupied with the insane notion that weightlessness is a matter of will and not physics.

He will then find himself 3) *bargaining* with the dismissive universe, as if it has ears, telling it that in exchange for him not attempting to alter it that it should attempt to reward his goodwill by going out of its way to *not* alter him. Upon realizing that his request for mutual respect is directed at a reality vast enough to make him puny by comparison and insignificant beyond measure, his voice so microscopic as to not even rise to the level of a whisper, he will turn his back on reality—*fuck it!* He will then bargain with *himself.* He will promise not to expect any tangible reward for his perseverance in exchange for the energy to continue failing miserably without succumbing to the madness that comes with continuing to fail miserably.

He will then find himself overcome with 4) *anger* when he realizes that the atoms conspiring to create the indifferent, booby-trapped universe are precisely the same atoms that conspire to make him, and that asking for preferential treatment for himself is as ludicrous as his asking the moon to not only have the power to sustain his sanity through unrelenting turmoil but also to make him special in the process.

He will then rely on 5) *denial* to help him forget that he ever wanted to—or even tried to—save himself or the world using such harebrained argumentation, for without such improvised deniability he'd never be able to look himself in the mirror, let alone fall asleep at night and then get up in the morning feeling sufficiently refreshed to begin the process of moving through the stages all over again, his self-aggrandizement restored, the world in flames and exploding like the most promising New Year's Eve ever.

<div align="center">* * *</div>

What follows is a book about how a lewd, four-eyed political satirist with a set of gnarled Staedtler pencils and a gummy eraser has been drawing his way through those stages day in and day out for the last half-decade. And by way of clarification, especially for those who may already know the lewd, four-eyed political satirist's work from seeing it posted online or published in magazines and newspapers where it is almost always presented as *editorial cartooning*, it is not editorial cartooning—or at least it isn't specifically, the same way that a guy who wears a cowboy hat isn't always trying to be John Wayne. Sometimes he's trying to be Jon Voight. Other times he's actually using his hat to beat back the sun. By way of explanation, I've included

a personal statement—a sort of grounds-of-opposition to my involvement in or association with the editorial cartooning profession—in the Appendix, the place that, like a human appendix, is notoriously invisible to most people until shooting pains and excessive vomiting indicate that it is there. That said, if at any time during the reading of this book you find yourself experiencing shooting pains and a sudden nausea that begs the question, *Who the fuck does Mr. Fish think he is?* look to the Appendix and drink some Pepto-Bismol.

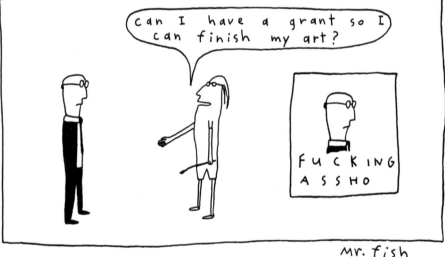

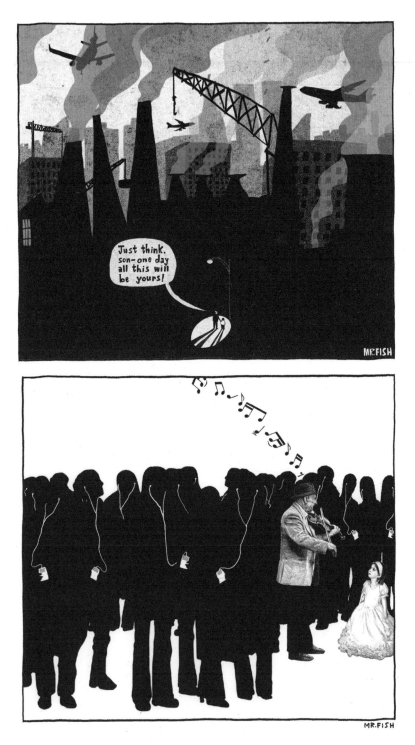

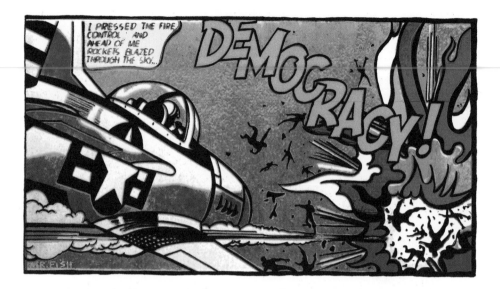

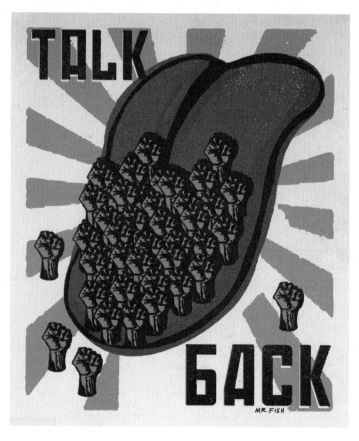

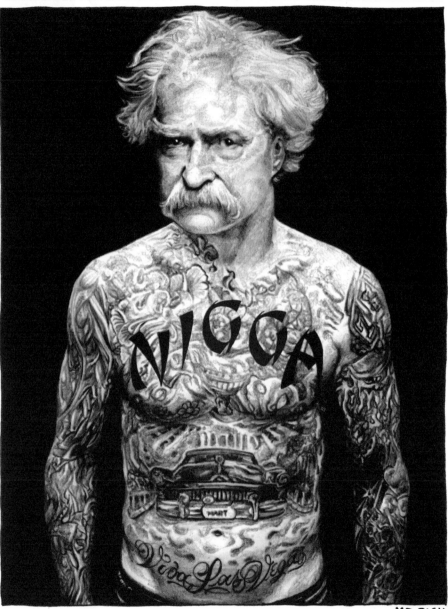

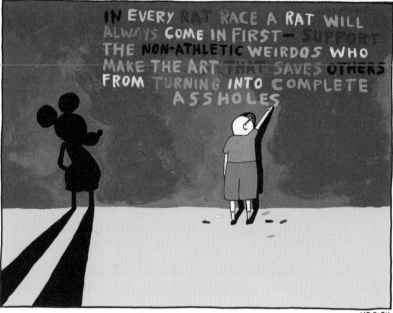

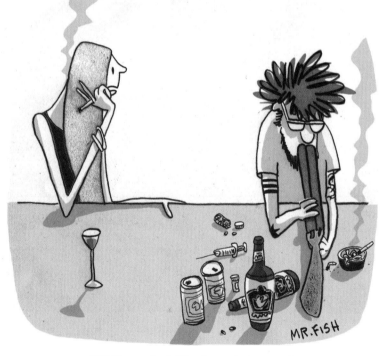

"Well, you look like the artistic type."

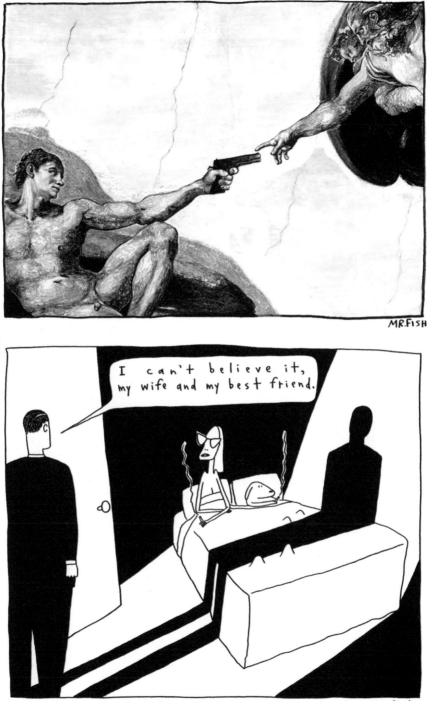

HAVING NEVER KISSED A GIRL BEFORE OR KNOWED PHYSICAL PAIN OR RECKONED THAT THE EARTH WAS OLDER THAN 6000 YEARS OR THAT FAGGOTS WEREN'T JUST PLUM CRAZY OR KNOWED WHAT A DINOSAUR WAS CEPT IN LEARNIN BOOKS, GOD WAS THRILLED THAT AMERICA STILL CONSIDERED HIS BLESSING ABSOLUTELY ESSENTIAL TO ITS SELF-RESPECT.

MR. FISH

We cannot change anything until we accept it.
Condemnation does not liberate, it oppresses.
—C.G. Jung

My first serious flirtation with wanting to become an expatriate came in 1973 when I realized that the "I'd Like to Buy the World a Coke" commercial by the Coca-Cola Company wasn't going to assuage the country's pandemic social unrest, nor was it going to end the war in Vietnam, nor was it going to abrogate the growing distrust and burgeoning paranoia spreading like yellow Communism between practically every competing sect and subset of American society. I remember the day. I was seven and it was a Thursday afternoon, sometime around the end of January, and I was sitting at the kitchen table with my homework spread out in front of me like a gutted animal. Rain was faintly drumming against the window like a thousand impatient fingernails, the tiny tapping begging entry into my shitty mood like termites in search of ailing wood, while I busied myself with my erasure, gouging the eyes out of the Founding Fathers who were

19

pictured on the cover of one of my library books. With my skull sandwiched between headphones the size of halved coconuts, I worked oblivious to anything but the music in my ears, figuring that unless the first Constitutional Convention in Philadelphia was attended exclusively by zombie vampires, then it couldn't be worth serious study by anybody.

After twenty minutes of intensely detailed vandalism, I stopped to flex my hand and remove my glasses and massage the concentration cramps out of my face. Rubbing my eyes into sparks and craning my neck this way and that, I caught a blurry glimpse of the television in the living room where I saw what looked like an angelic choir of multicultural hippies at the beginning of the then-famous hilltop Coke commercial. Even with B.J. Thomas coming out of the massive stereo console in the dining room and traveling like heroin through the spiral cord that snaked out from beneath the heavy cherry lid that closed from the top like a coffin, stretching across the room and into my headset—even with all that wonderfully pungent Bacharachian cheese serenading my future muttonchop sideburns, Sansabelt slacks, and heavily cologned misogyny with "Little Green Apples"—I swore that I could still hear the commercial's beatific opening line, "*I'd like to buy the world a home and furnish it with love . . .*" and I sighed.

How was it possible that such an elaborate jingle about the unifying power of a soft drink—a liquid that, according to rumor, was awesome enough to dissolve the hood off a Chevy Impala if allowed to puddle!—couldn't convince everybody in the country to abandon all their derisive loyalties to all the contentious tribal bullshit that amplified their differences? After nearly two years of asking everybody in America to participate in this televised rehearsal for peace and optimism, what had happened to make the song no more useful to any of us than a fistful of coins tossed into the mud at the bottom of a wishing well? What are people doing anymore, anyway, tethering their hopes and dreams to money, like lashing Mafia snitches to stones, and then throwing the whole doohickey into the water at the bottom of a hole—a *grave* really? After all, once you make the proper adjustments for inflation, it should be obvious that loaves and fishes for the multitude cannot possibly be free anymore like they were in the Bible story. In fact, "*I'd like to buy the world a home and furnish it with love . . .*" sounded to me like something—at least by intent—straight from the Sermon on the Mount, and might've been had Jesus Christ been alive in 1973, not as a destitute beggar of men's souls like He ended up being, but rather as what he started out as, namely a carpenter who earned enough money to buy shit for people.

Returning the glasses to my face and staring out into the rain, I felt as if I could see past the horizon and into the nation's dreary future, believing that if it weren't for the weather and my having such a crappy bike whose chain was always falling off, and if it weren't for the seventeen quadrillion gallons of Atlantic Ocean that sloshed between me and the wrought-iron café chair that I imagined myself in, whiling away the Parisian afternoons with absinthe in my beard, a cracked monocle in my eye, and a load in my knickers, I'd be an expatriate, following in the famous footsteps of Henry James and Ernest Hemingway and e.e. cummings and James Baldwin.

When you're seven years old the world is a much smaller place, but that doesn't mean the moral physics that determine the heights of human misbehavior and the depths of human benevolence are any different than they are for everybody else. In fact, just as an engineer might want to know how competing properties of gravity and momentum will interrogate the integrity of a scale model before investing his energies into constructing something for application in a public space, a seven-year-old is much more likely than an adult to interrogate the smaller version of the world with his curiosities and to assume that the resulting theories he develops will have some practical application to common knowledge. And it isn't just another case of somebody knowing less and, therefore, suffering the delusion that his perception of the universe actually reflects the fixed parameters of it. A seven-year-old does not require decades of paying taxes and hard living and a college degree to know how he should react to the dominant culture's rather obvious and clearly dismissive suggestion that he and his humanitarian ideals should just fuck off to make room for ideals that are much more hubristic and competitive and in need of authoritarian control. In fact, one could say that people know that oppression is wrong *despite* the indoctrination they're likely to receive as tax-paying, degreed, decades-long participants in every modern industrialized society this side of the first bullwhip and leg irons.

Still, peering out through the rain in contemplation of what the failure of the Coke commercial really meant to me, I allowed my focus to shift away from the future and settle on my own reflection in the window. It was then that I started to wonder if expatriation from America, for those who actually end up doing it, might not ultimately feel a lot like a prolonged version of the sort of impulsive, temporary breakup that can send somebody out of their house and down the block and onto a barstool, or maybe just into their bedroom. I thought about the night when my mother turned off *Laugh-In* with her foot and told me that it wasn't coming back on until I took out the

trash, and how I stood up and went into the kitchen and shoved an entire box of Tagalongs down my pants and stepped outside, threw the trash cans against the telephone pole at the foot of the driveway, and then headed into the woods and followed a trail overgrown with weeds and loony with the chirping of crickets to the sandy bank of a brackish lagoon that stank of tar and dead crabs, and sat down on an old tire and devoured a dozen cookies as destructively as I could, smashing them on my face like a cartoon character as I ate, even tossing the box and cellophane into the water behind me. After fifteen minutes I started to notice how my rage was cooling and that the only way I had of reheating it was to hyperfocus on the satisfaction that came from leaving my house. It was as if I could only feel vindication for my actions when I was deliberately stoking the flame of my victimization and comparing where I was to where I wasn't. After another half an hour of this I became so mentally exhausted that I went back home and climbed into bed with my clothes on.

Years later, when considering expatriation from Ronald Reagan's America, and then George H.W. Bush's America, and then Bill Clinton's America, and then George W. Bush's America, and then Barack Obama's America, I would try to temper my instinct to flee by recalling my experience at the lagoon and how empty it felt to have my identity wholly determined by relativism; not by who I was at a particular moment, but by who I *wasn't*. I would then force myself to recognize the same skewed logic in so many of the moral and ethical judgments made by so many in support of the elite power institutions that I so detest—judgments made using this bogus and spooky deductive reasoning predicated on nothing but comparative equations: *Vote for me because I am not the other guy. I may be an anus but the other guy is an asshole. Oil is good because it is not coal. Natural gas is good because it is not oil. War is good because it is easier to wage than peace. Sucking the cock of your oppressor is good because not sucking it might get your head smashed in. Etc.*

In contempt of everyone and everything, then, the question became: should I leave America because I feared contracting her moral and ethical decay, or did I need to live inside this dying society to contract the disease of its agony, eventually succumbing to it, in order to give credibility to the complaints I make and, as a so-called political cartoonist, the work I produce? Will my depression qualify as some sort of expertise in recognizing how bad things really are, and will such expertise eventually manifest itself in some way that will enable me to cure certain social ills just for the sake of self-preservation? After all, if I allow myself to become infected with a spiri-

22

tual cancer, won't I be more committed to finding a cure for it than if I fled to deliberately avoid its contraction?

Sitting at my kitchen table when I was seven, I also knew that expatriation could backfire for wholly different reasons, remembering from a school assembly that Albert Einstein, supposedly the smartest guy in the history of smart guys, left Germany in 1933 only to end up—for the next twenty-two years—in the same New Jersey where I was sitting and that I was so desperate to leave. Sighing for a second time, I suddenly noticed the television reflected in the glass that I was looking into and saw what I thought was the same Coke commercial that I'd turned away from several minutes earlier. Curious to find out how the "I'd Like to Buy the World a Coke" song could still be playing, I turned back toward the living room and saw, this time with glasses, that the singers on the TV were not the multicultural Coke hippies I thought they were, but rather they were local high school students wearing crisp white shirts and standing in a gymnasium. Removing my headphones, I now heard that they were singing "God Bless America" to commemorate the passing of Lyndon Baines Johnson, whose funeral was all over the news and preempting normal programming.

Turning away from the angelic singing and pretending that I'd just heard the young patriots say something about wanting to *teach the world to stink*, I closed my eyes and made a wish to the unmistakable sound of a wishing well gorging itself on dreams that really do come true.

MR. FISH

AMERICAN CLASSIC

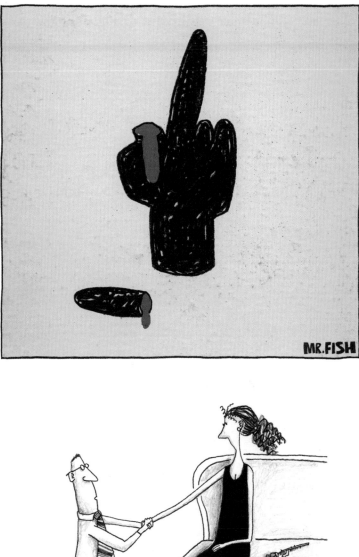

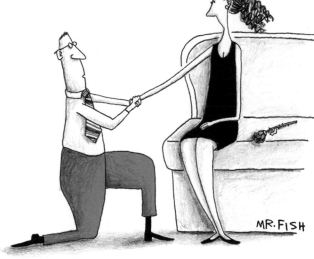

"Of course it'll last forever – you're a Jew and I'm an anti-Semite."

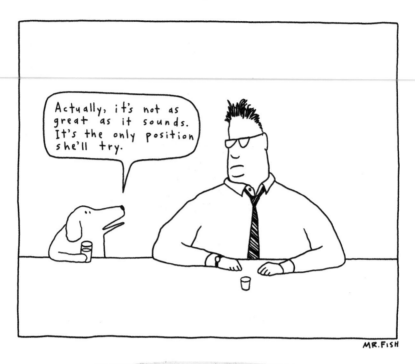

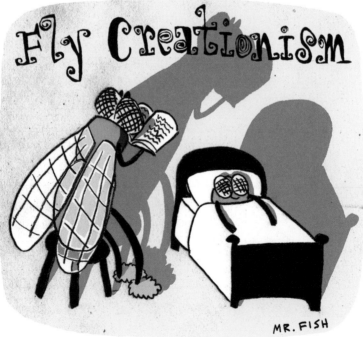

"In the beginning God made a whole lot of shit..."

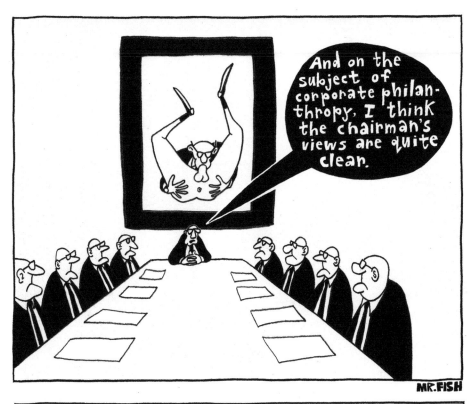

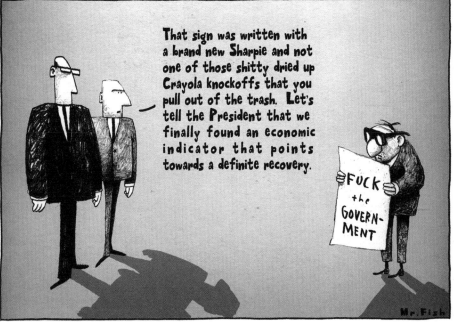

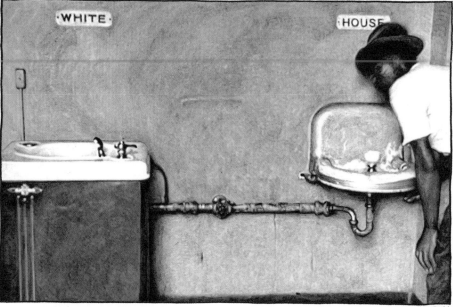

A BRITISH SOLDIER HELPING A LOST IRAQI BOY BY SHOWING HIM WHERE HIS MUMMY AND DADDY WENT.

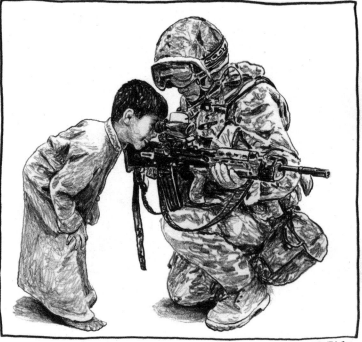

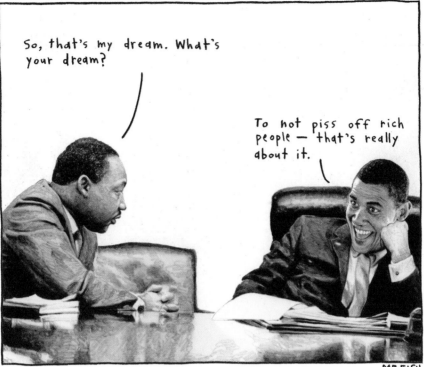

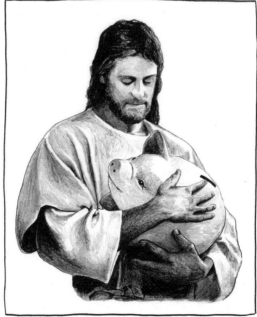

SCOOTER IN 1959 LOOKING AT A FUTURISTIC COMIC BOOK ABOUT HOW AWESOME LIFE WILL BE IN THE 21ST CENTURY

HENRY MILLER GETTING AN IDEA FOR A NOVEL AND SUDDENLY NOT BEING ABLE TO SEE HIS CROSSWORD PUZZLE.

Cupid afraid that his parents are starting to suspect
that he's discovered masturbation.

MR.FISH

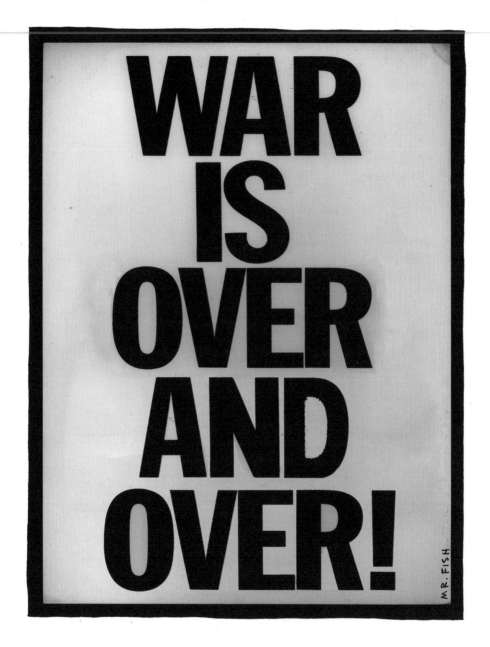

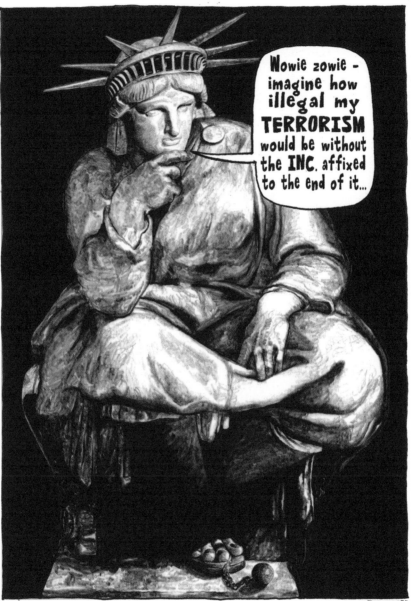

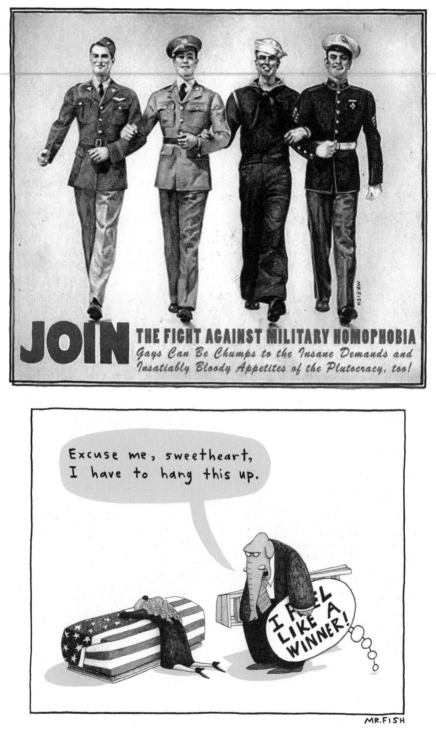

PRESLEY VON DONNEGAN REGRETTING THAT HE HAS BUT ONE
SET OF PARENTS TO GIVE TO HIS COUNTRY.

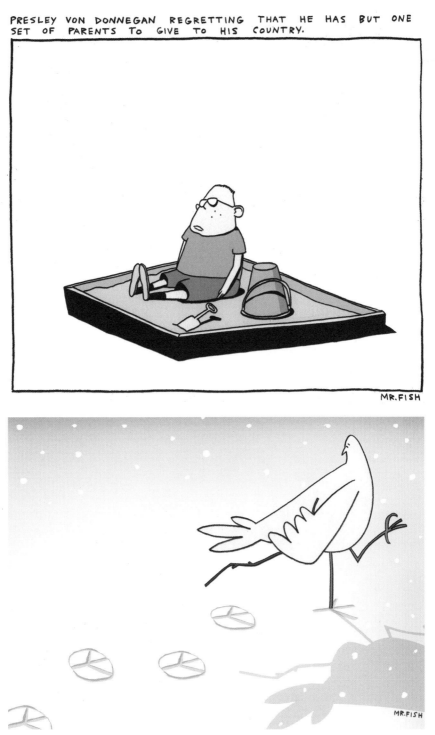

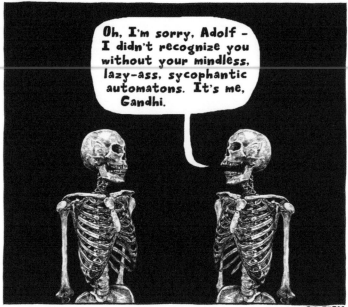

THESE INSURGENTS ALSO WENT KICKING AND SCREAMING INTO DEMOCRACY AND NOW MANY OF THEM OWN THEIR OWN TRAILERS.

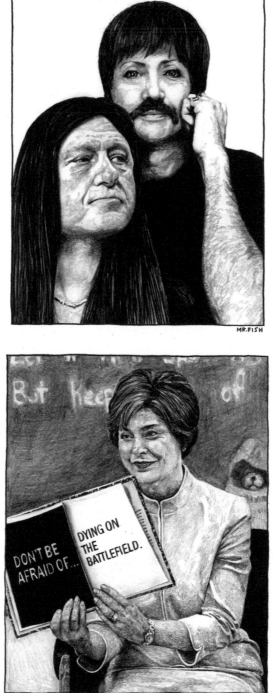

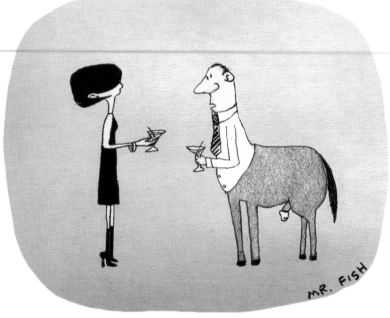

"Well, actually, I'm only half Jewish."

A WALL STREET EXECUTIVE FOLLOWING
THE LETTER OF THE LAW.

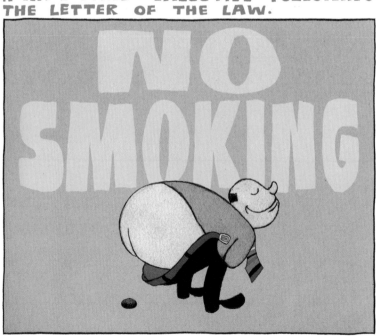

"Aw, Jesus – I better pick up this soap before somebody steps on it."

"Minus the monkey with the fork in his head who's eating the face off of Sister Connie, this reminds me of a pretty good joke."

"Before dismissing my observation so flippantly, Mr. Saltzman, you should take a moment to consider who in this room is the professional."

"Other side."

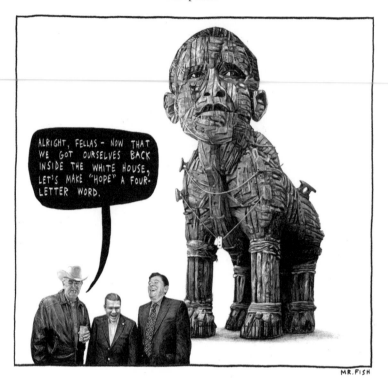

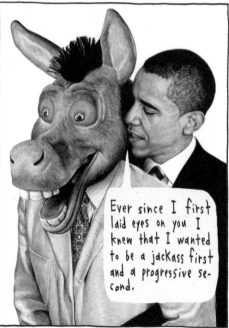

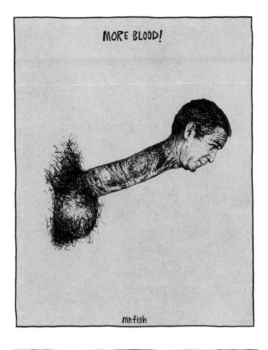

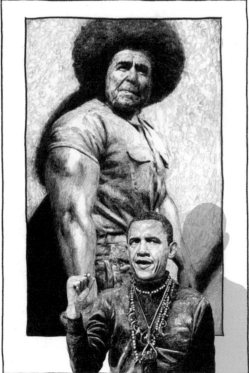

See Jane's Dick.

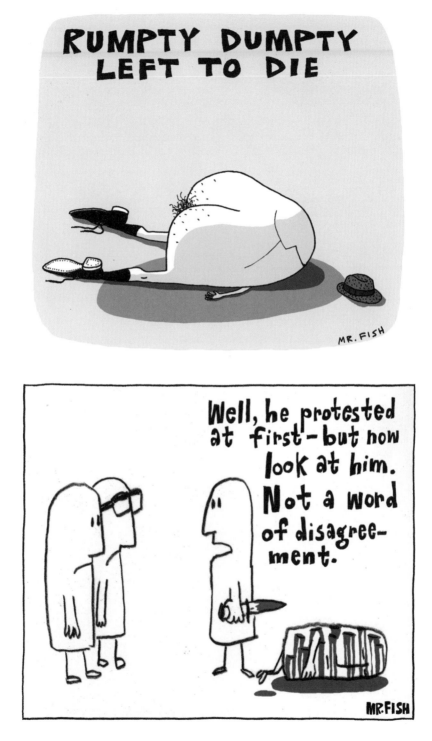

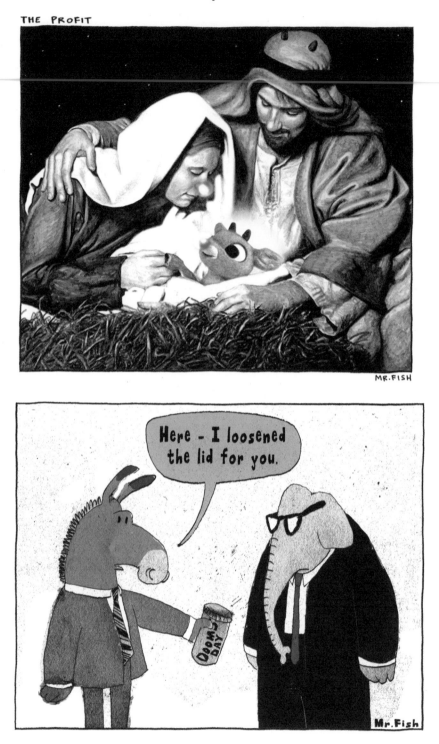

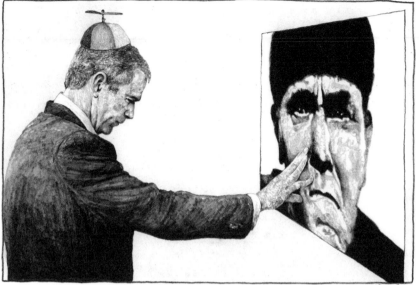

Giddy with excitement, Kevin couldn't wait until the day when he was old enough to become a hero, himself, and get a real one.

GEORGE BUSH WATCHING HIS DAUGHTERS GET THEIR HEADS BLOWN OFF
TO PROVE HOW ENLIGHTENED THE WESTERN FORM OF DEMOCRACY
THAT HE'S ASKING MIDDLE EASTERN DADDIES TO EMBRACE AND
CELEBRATE IS.

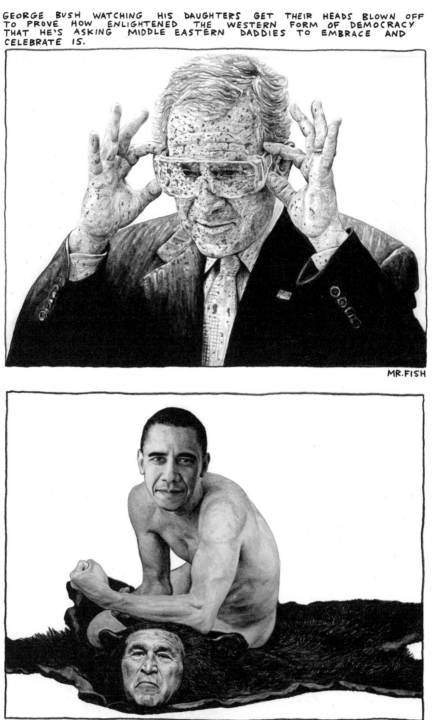

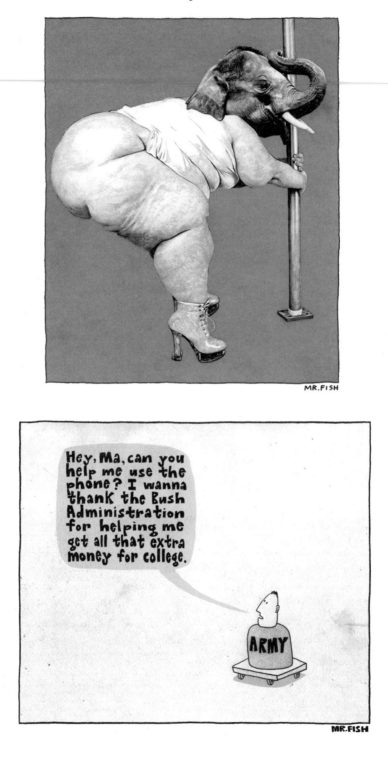

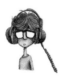

GEORGE AND BARBARA BUSH PRAISING THEIR FIRST BORN
FOR MASTERING THE POTTY TRAINING SKILL GUARANTEED
TO DISTINGUISH HIM FROM ORDINARY WORLD LEADERS LATER
IN LIFE.

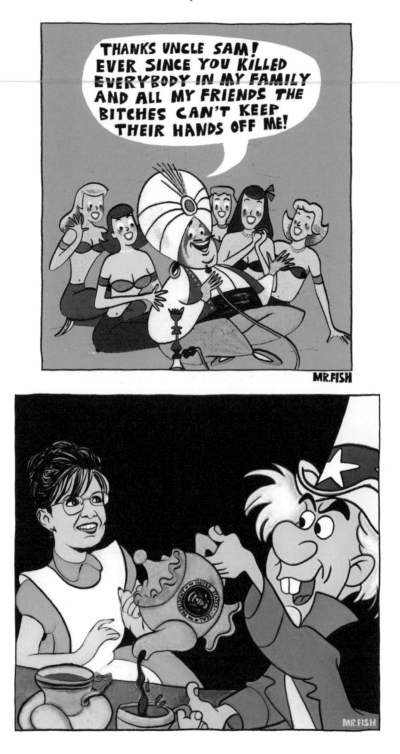

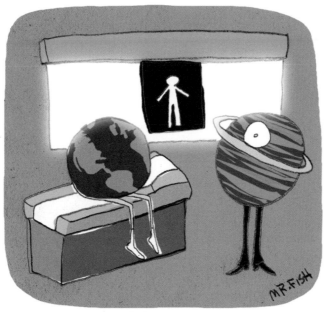

"I'm afraid that it's terminal."

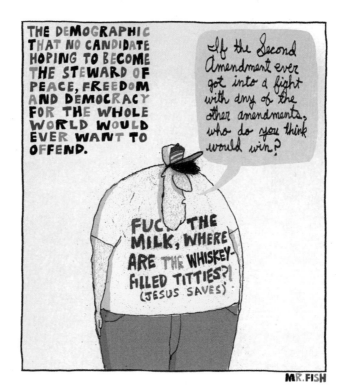

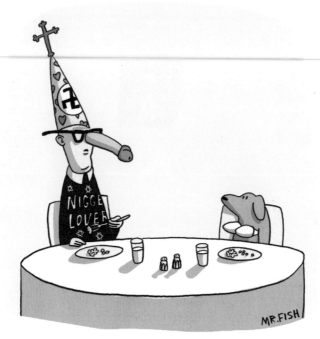

"This feels like a Tuesday to me."

"They didn't tell me - maybe for licking my own ass in
broad daylight? What are you in for?"

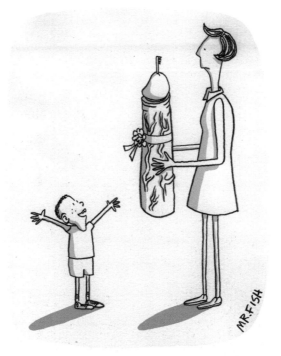

"It's a fucking toothbrush!"

JESUS AS A YOUNG MAN LEARNING CARPENTRY.

DEPRESSION

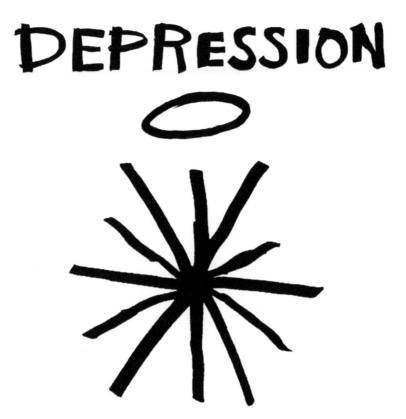

Politics is the art of looking for trouble, finding it everywhere,
diagnosing it incorrectly, and applying the wrong remedies.
—Groucho Marx

In 410 B.C., the Greek playwright Aristophanes wrote a play called *Lysistrata*. The story was about Athenian women barricading themselves inside the Acropolis in protest of the Peloponnesian War and promising to withhold sex from their husbands until they agreed to declare peace with Sparta. On March 3, 2003, eight hundred readings and full productions were performed in fifty countries to protest the United States' pending invasion of Iraq. What happened after that? The United States invaded Iraq and *Lysistrata* remained a relevant piece of literature for people who wouldn't be able to shoot straight anyway if asked to participate in an invasion.

No surprise. That's how shit usually goes down. And, chances are, that's how shit will always go down.

Kurt Vonnegut, who made me want to put down the air guitar and become a writer when I was fifteen by drawing a picture of his asshole with a felt-tipped pen, once said that protesting wars was not unlike protesting glaciers, and that the weaponry of artistic expression against state tyranny was roughly equivalent to a custard pie being dropped from a stepladder six feet high. I believe he was right, being something of a war-protesting pie-dropper myself. However, I don't think he wanted the sentiment to rest there as some sort of defeatist justification for political noninvolvement. In fact, I think that, as evidenced by his own persistent pie dropping, he felt perhaps the arts community shouldn't always wait for some blatant expression of state tyranny, like a war, to signal when a pie should be dropped from a six-foot ladder. He seemed to believe that pies should be hitting the floor all the time, and not just from the hands of artists but from everybody with a conscience. That way, his work seemed to imply, there will eventually be enough custard on the floor so that any asshole who attempts to shoot a gun or tries to run another person through with a bayonet will fall down and break his neck without forcing a single pacifist to compromise his or her commitment to nonviolence.

Plus, it's darling when nobody can stand up for laughing their asses off. And the clock is ticking.

Vonnegut died on April 11, 2007, about a month before I was scheduled to interview him in Los Angeles about his recent book, *A Man Without a Country*, which was ostensibly about the author's disenchantment with what George Bush and Dick Cheney had done to our once promising American democracy, but was really about something much darker, namely his utter disgust over the much grander stupidity of the whole human species. Equally disgusted by the evil that men do by intent as *unintent*, Vonnegut had finally found himself in the same nihilistic lookout famously occupied by his own literary hero Mark Twain, who said in his exquisitely depressing, albeit all too convincing essay, "On the Damned Human Race":

> *I have been reading the newspaper. I do it every day knowing full well that I shall find in it the usual depravities and basenesses and hypocrisies and cruelties that make up civilization, and cause me to put in the rest of the day pleading for the damnation of the human race. I cannot seem to get my prayers answered, yet I do not despair.*

Whether one is talking about the mechanics that maintain the fixedness

of atoms or the cohesion of an entire galaxy, it is never unanimity that gives durability, or even physical body, to matter. Perhaps human behavior is no different. Perhaps one's belief that the human race might survive longer if it were to align all opinion along the same moral compass is as misguided as the belief that matter would better survive if one were to convince protons and electrons to agree on a single charge. Perhaps the mere fact that everybody can think differently is, as it is with atomic particles held together by opposing charges, all the proof we need to know that everybody will always disagree and that attempting to alter that fact may be the most catastrophic sort of mad science.

Hearing Vonnegut, just weeks prior to dropping dead, tell Anna Maria Tremonti, the host of the CBC Radio One news program *The Current*, who had just pummeled her guest mercilessly with platitudes as polite as balled Kleenex and then thanked him for talking to her, to "go jump in a lake," seemed less a cantankerous farewell and more a glorious reassurance that all was well with the cosmos.

On April 10, 2007, I decided to participate in a magnificent failure sure to contribute to the balance of the cosmos. When it was over, Eli Pariser, executive director of MoveOn.org, spoke to me and all the other people involved through a laptop speaker and said, "Tonight was a historic event." Everybody in the room clapped while I sat on the rug picking cookie crumbs off my pants and feeling a little bit embarrassed by the pronouncement, figuring that a truly historic event should be more self-evident than needing to be pointed out—"We've done something *historical* tonight!"—twice in a row.

The event took place at the beginning of the 2008 presidential campaign season and was to be, according to the e-mail invitation that I'd gotten the week before, the *"very first ever Virtual Town Hall meeting."* It promised to involve thousands of house parties across the country. It would give hundreds of thousands of people, via the Internet, the chance to *"hear directly from candidates"* and to *"inject* [progressive perspectives] *into the debate early"* so that presidential hopefuls *"know where we stand,"* thereby allowing us to *"shape what issues count in '08."* There was mention of participants getting a *"front-row seat"* and *"hearing the candidates answer questions straight from MoveOn members' mouths,"* the old dynamic of not being able to *"connect with presidential hopefuls face-to-face"* being *"turn*[ed] *on its head."* The description read like an impossible promise, like it was being hawked by a sideshow huckster peddling a fantastic stunt that was wildly appealing, not because of the triumph that its

success would inspire but rather because of the perverse thrill that its failure would guarantee.

As if I were signing up to watch a pair of Siamese twins play tennis against each other, I entered my name and phone number into the online invitation and was promptly given the Pasadena address where I'd need to go in order to *"make history"* with my *"fellow progressives."*

With my prerequisite laptop in hand, I arrived at my host Yuny P's house dressed like Richard Lewis, all black, like an exclamation point, and sauntered into a living room the color of pancake batter and decorative hotel soap: puce and tan and waiting-room white. A half-dozen large, soft-spoken women rested on sofas and chairs, appearing as if they'd been poured into their immense T-shirts and Fila sneakers by a pastry chef, none of them wishing to meet my eyes. They looked like the moms of the hipsters that I wanted to hang out with. Smiling hard into their peripheral vision, I considered reaching for my car keys and putting on my best *oops-I-forgot-to-douche-the-cat* face, when I was grabbed suddenly by Yuny, a Latina grandma in slippers with a face like the moon. "You brought a computer!" she said. "Good!" She turned me toward a TV the size of Damien Hirst's shark tank and asked, "Can we get the computer inside the television so that everybody can enjoy it?" Although I was dressed in black, I wanted to tell her that I was not a witch.

"Well," I said, "what kind of cords do you have?"

Yuny bent down next to the base of the gigantic picture tube and replied, "I have red, yellow, and . . . white."

The fictional cat that I had at home fanned its putrid crotch with a magazine and mouthed the words *lousy cocksucker* while staring at my picture on the mantle.

Two excruciating hours later, after the Virtual Town Hall had been revealed to be nothing more than a prerecorded collection of brief statements by seven democratic presidential candidates—the chance for MoveOn members, we'll call them *virtual* progressives, to experience the comedic high jinks of Bill Richardson saying *mahslums* over and over again and Hillary Clinton chasing her personal integrity around her own narcissistic political ambitions like Sambo's tigers around a tree—I felt no more reassured as to the health and well being of our system of self-government than I was prior to arriving. In fact, I worried that virtual democracy was being tested to replace real democracy and that, given the joy on the faces of everyone around me, it had a pretty good chance of succeeding.

On the way out, an awkward bald guy in glasses as thick as hockey pucks, his eyes I imagined having been destroyed by hours of scouring the *Sgt. Pepper's* album cover for clues corroborating the death of Paul McCartney, stopped me to say that Dennis Kucinich was our best hope for peace in the world.

"I tend to agree," I answered. "Unfortunately, the presidential election is a beauty contest and Kucinich is too short and too funny-looking to win."

"He's not short!" said the guy, a faint Klingonese accent buried inside his tongue.

"He's not?"

"No, I've met him. He comes up to here on me." He touched the bridge of his nose.

"Were you two dancing?" I asked.

"What?"

"Nothing. I'd just heard he was short."

"Maybe here," said the guy, touching his upper lip.

I left feeling as if the political viability of sustaining a healthy social democracy into the twenty-first century was sinking—or maybe I was just getting taller.

And the next day Kurt Vonnegut was dead.

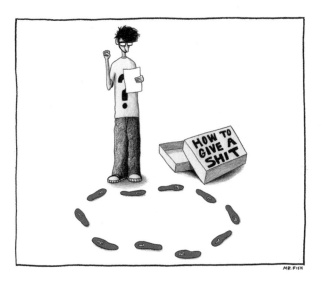

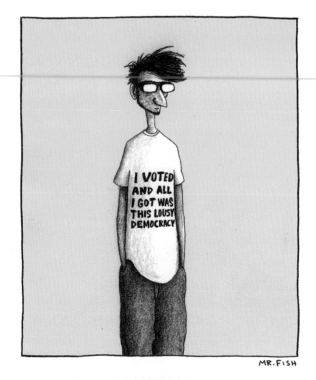

CHEESE

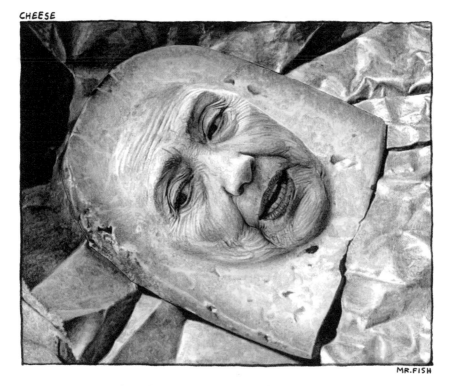

MR.FISH

THOMAS JEFFERSON STEPPING FROM THE EXPLODED HEAD OF A DEAD IRAQI BOY AND FEELING FUCKING AWESOME.

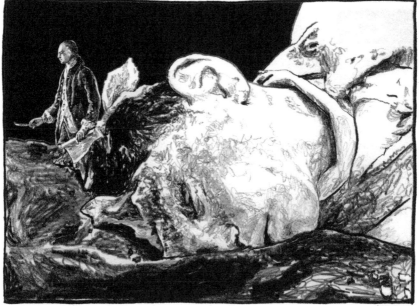

MR.FISH

Depression

LITTLE BILLY CHOKING BACK THE TEARS AND WONDERING
IF WE'LL EVER HAVE A WHITE PRESIDENT AGAIN.

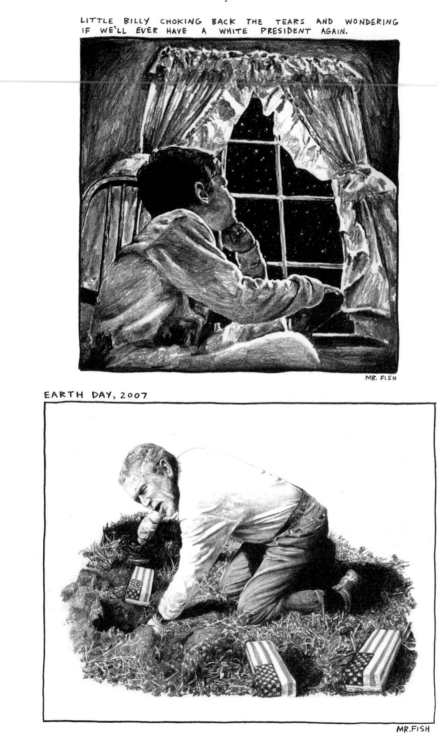

EARTH DAY, 2007

MR. FISH

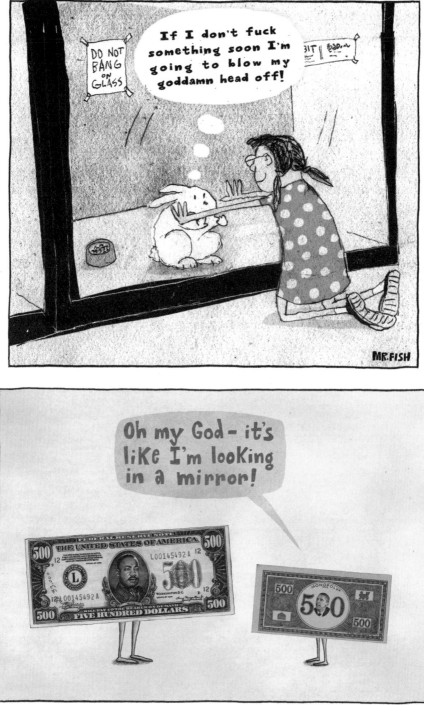

65

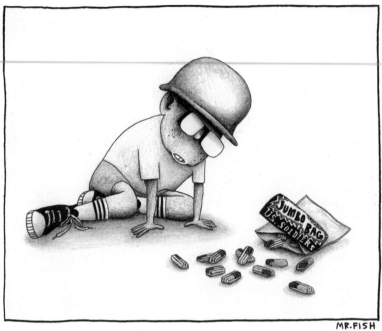

MR.FISH

JESUS CHRIST SITTING IN A SECRET PRISON WITH CRUSHED TESTICLES AND NO FINGERNAILS BECAUSE OF HIS MIDDLE EASTERN LINEAGE.

MR.FISH

BARACK OBAMA GETTING READY TO ADDRESS THE CONCERNS OF
THE ANTI-NUCLEAR MOVEMENT, HAVING ALREADY ADDRESSED
THE CONCERNS OF THE ANTI-WAR MOVEMENT, THE ANTI-CORPO-
RATION MOVEMENT, THE ANTI-WARRANTLESS SURVEILLANCE
MOVEMENT, THE ANTI-SECRET RENDITION AND TORTURE MOVE-
MENT, THE PRO-ENVIRONMENTAL MOVEMENT, THE PRO-CHOICE
MOVEMENT AND THE PRO-PALESTINIAN MOVEMENT.

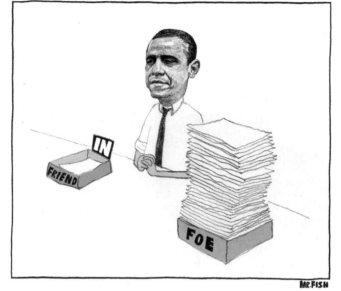

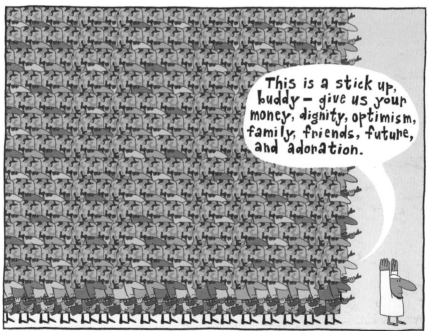

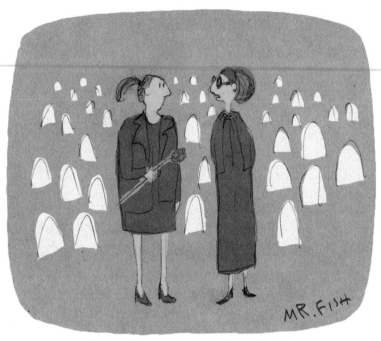

"Ask anybody - patriotism is the new black."

LEADER OF THE REVOLUTION

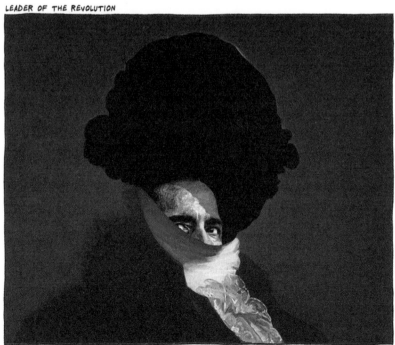

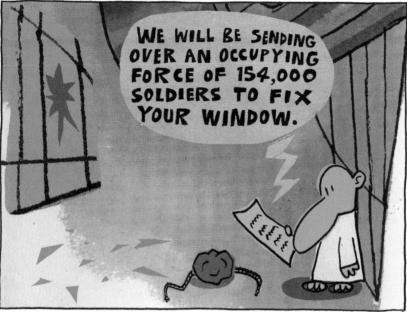

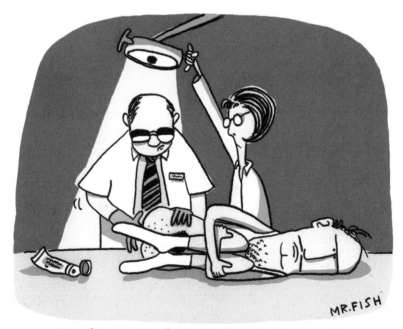

Pinocchio regretting the decision he made 51 years earlier
that gave him a prostate.

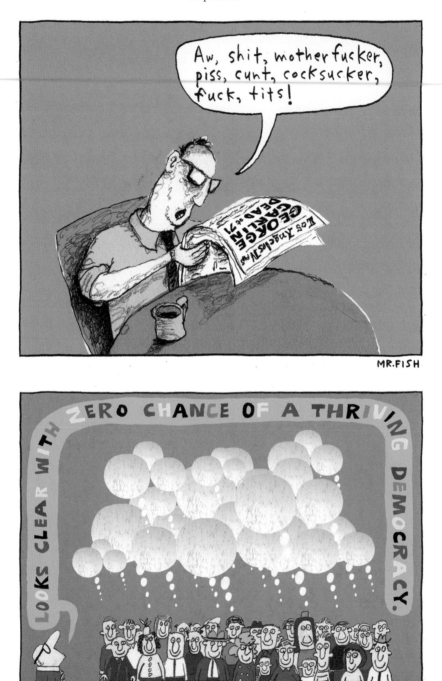

MR. FRECKLES AFTER MISREADING DARWIN'S CHART OF EVOLUTION AS AN IMPROVEMENT PLAN.

MR. FISH

MR.FISH

71

AN EMPEROR WITHOUT CLOTHES, WHEN LAVISHED WITH PRAISE FROM THOSE
ENAMORED BY HIS BEAUTY, WILL NEVER KNOW SHAME AND WILL NEVER LEAD
WITH HUMILITY OR EMPATHY OR GRACE.

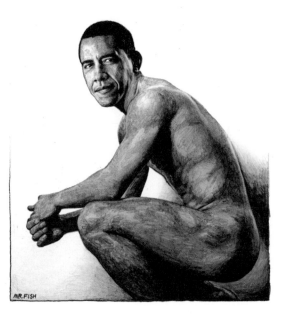

MR. FISH FINALLY HITTING THE WALL ON THE 2008 PRESIDENTIAL CAMPAIGN, NO LONGER ABLE TO DRAW ANY MORE CARTOONS ABOUT THE FUCKING REPUBLICANS DOING THEIR AW-SCHUCKS DARNEDEST TO APPEAL TO THE DIMMEST WITS IN MIDDLE AMERICA WHILE THE FUCKING DEMOCRATS PULL THEIR PUNCHES BECAUSE THEY, TOO, WANT VOTES FROM THE DIMMEST WITS IN MIDDLE AMERICA AND THEY FIGURE THAT IF THEY SAY, "HEY, MORONS, THE GOP IS PLAYING TO YOUR BONE-CRUSHING IDIOCY!" THEN THE DIMMEST WITS, NATURALLY UNWILLING TO ACKNOWLEDGE THEIR GULLIBILITY, WILL HATE THE DEMOCRATS FOREVER AND EVER AND FULLY EMBRACE THE BULLSHIT PRAISE FROM THE REPUBLICANS WHO, RATHER THAN CALLING THE DIMMEST WITS STUPID, WILL REFER TO THEM AS PLAIN-TALKIN', HARD-WORKIN', STRAIGHT-SHOOTIN', JESUS-LOVIN' AMURKINS WHOSE BELIEF IN THE 2nd GRADE NOTION THAT BONE-CRUSHING IDIOCY IS REALLY JUST AN ULTRA BASIC FORM OF FOLKSY WISDOM THAT RECOGNIZES VIOLENCE AS HEROISM, TRIBALISM AS PATRIOTISM, FANATICISM AS SPIRITUALITY AND RAMPANT PARANOIA AS CRITICAL THINKING MAKES THEM MORALLY SUPERIOR TO ANY OTHER SOCIETY ON EARTH.

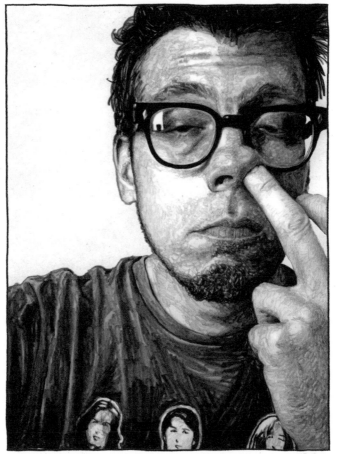

MR. FISH

Depression

Barack Obama telling all the Muslims in the Arab world how deeply he respects and cares about them.

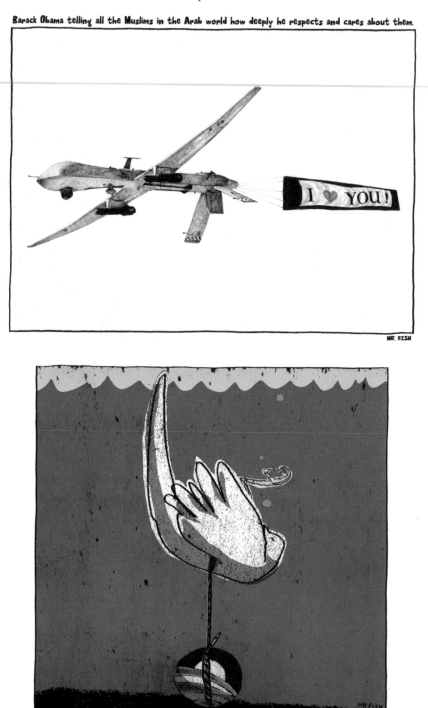

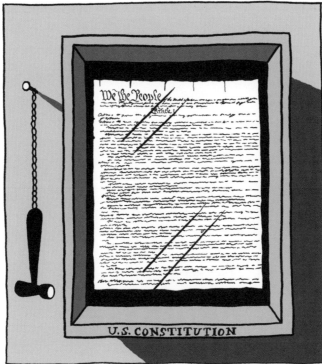

75

"EVIL EVENTS FROM EVIL CAUSES SPRING." -ARISTOPHANES

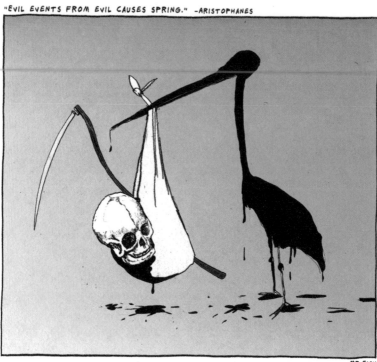

MR. FISH

MR. FISH

"It wasn't a dream as much as a nightmare that one day my legacy would be
celebrated when a black man would become President of the United States by
coddling big business, supporting domestic spying and touting the virtues
of a foreign policy predicated on the misconception that America has a
responsibility to police the entire world."

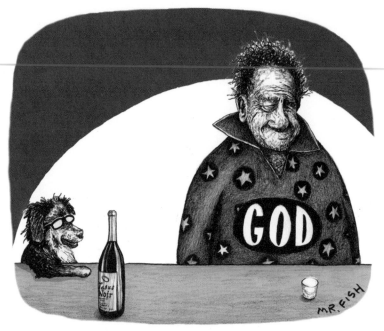

"Did you ever worry that not only are you dyslexic but that I'm dyslexic, too?"

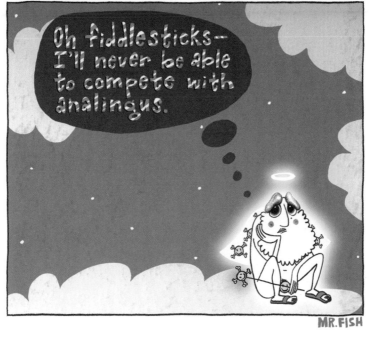

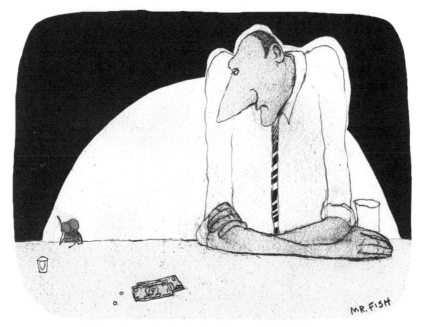

"You know - same shit, different day."

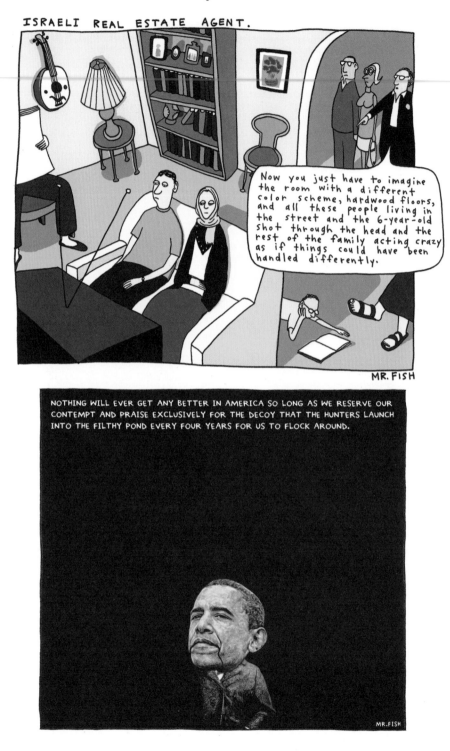

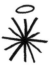

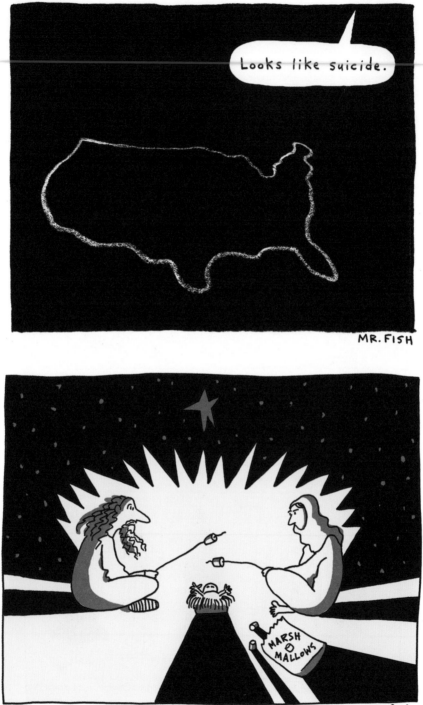

STAIRWAY TO DEMOCRACY. STAIRWAY TO FASCISM.

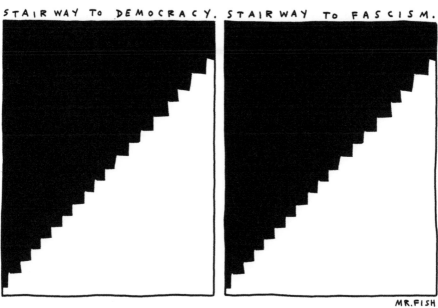

MR. FISH

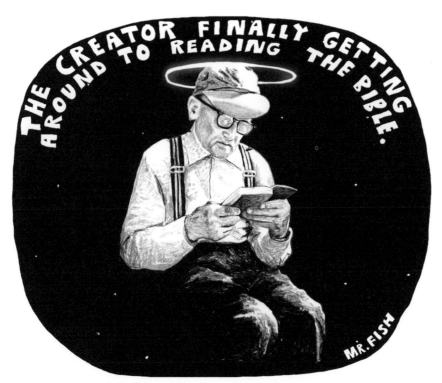

THE CREATOR FINALLY GETTING AROUND TO READING THE BIBLE.

MR. FISH

"(Hey-seuss)? Oy vey – I have a Hispanic son!"

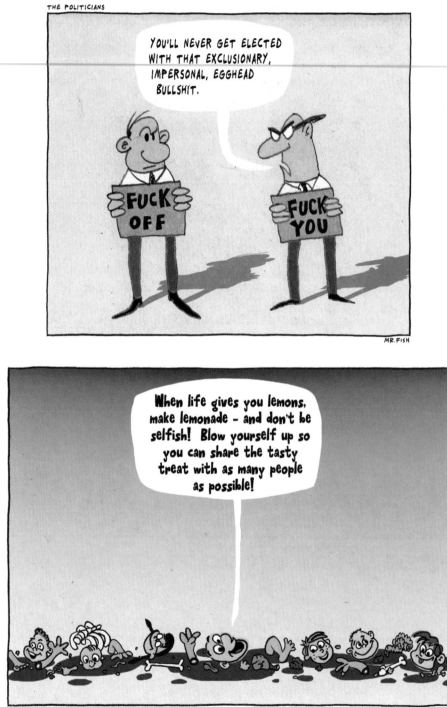

The United States Congress finally deciding that democracy would best be served by the legislative branch of the government listening to its constituency and serving the will of the people.

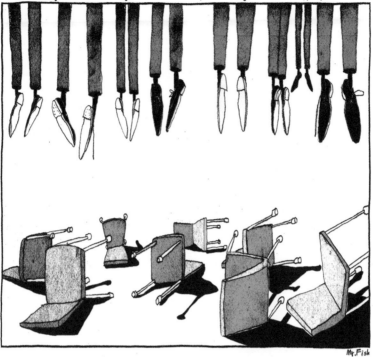

After 24 hours of excruciating humiliation, Frosty finally came to the depressing realization that there was no law in the universe that said one's creator couldn't just be a bored asshole with a shitty sense of humor and too much time on his hands.

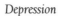

THE UNITED STATES SEALING OFF ITS
BORDERS.

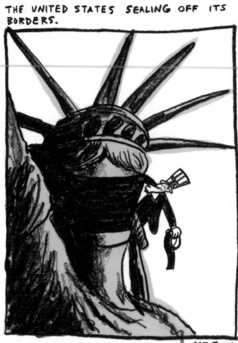

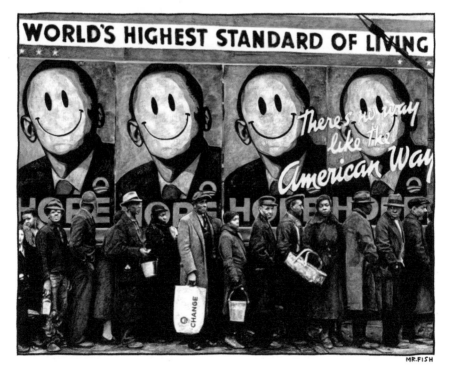

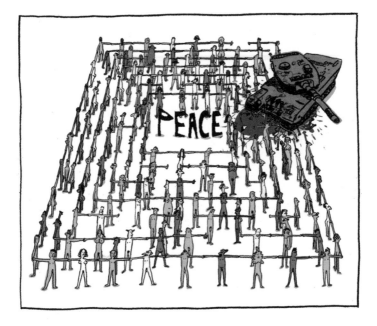

CURIOUS AS TO WHY AMERICAN POLITICS IN THE 21ST CENTURY SUCKED SO
BAD, ROGER DECIDED TO LOOK AT THE HISTORICAL RECORD AND DISCOVERED,
TO HIS HORROR, THAT SUPERMAN'S MOST DEBILITATING WEAKNESS WAS NOT
HIS SUSCEPTIBILITY TO THE EFFECTS OF KRYPTONITE BUT RATHER HIS
THUGGISH INABILITY TO FACE ANY INTERNATIONAL CRISIS WITH DIPLOMACY.

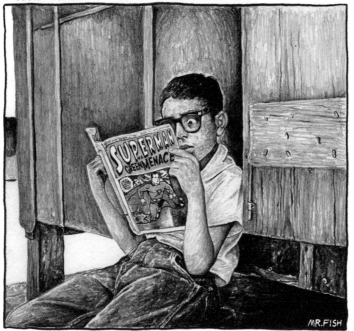

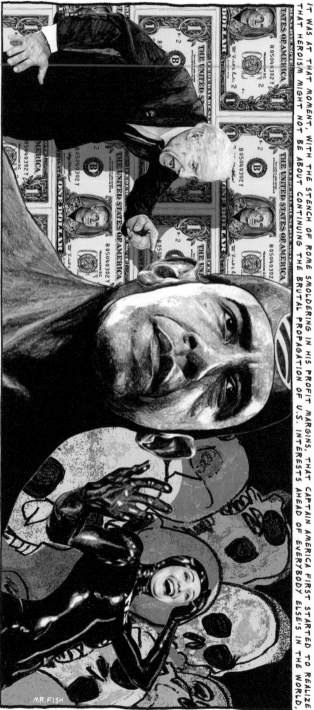

IT WAS AT THAT MOMENT, WITH THE STENCH OF ROME SMOLDERING IN HIS PROFIT MARGINS, THAT CAPTAIN AMERICA FIRST STARTED TO REALIZE THAT HEROISM MIGHT NOT BE ABOUT CONTINUING THE BRUTAL PROPAGATION OF U.S. INTERESTS AHEAD OF EVERYBODY ELSE'S IN THE WORLD,

BUT RATHER IT MIGHT BE ABOUT HAVING THE COURAGE TO REMOVE THE PERIODS FROM THE NATIONAL MONOGRAM AND TO ALLOW THE REMAINING "US" TO ENCOMPASS ALL OF THE INTERESTS OF EVERYBODY IN THE WORLD. ECONOMIC TRIBALISM BE DAMNED ALONG WITH THE ADOLESCENT APPEAL OF THE COMIC BOOK MORALITY THAT SUSTAINED THE BOGUS AND LETHAL FICTION THAT MADE WHAM! AND POW! AND KA-BLOOMY! THE ONLY FUEL AVAILABLE TO OUR FORWARD MOMENTUM.

MR. FISH

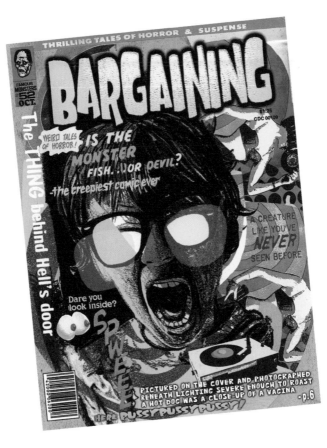

Computers are useless. They can only give you answers.
—Pablo Picasso

What would Jesus do? is not the right question.

Or at least it isn't the complete question. The complete question is: *What would Jesus do without nepotism?* It's easy to have a big mouth and a shitload of opinions about what's wrong with everybody in the world when your dad is the guy who invented the world and everything that's wrong with everybody in the world. I'm sure that the son of the father who invented the pay toilet had a lot to say, too, about how aggravating and unenlightened poor people were for always crapping on the floor. Maybe the question should be a broader one, something like: *Why is it so necessary for me to be critical of my own imperfections at the insistence of a God in whose perfect image I was*

so famously created? That's like a ball drawing a circle on a piece of paper and then expecting the circle to damn itself for not being able to bounce. And since when did God's so-called *perfection* as a point of comparison become convincing as an enviable ideal, anyway? Sure, He can make a zebra, and sure, He has X-ray vision, but at least I've kissed a girl before and know what a fucking dinosaur is.

A translucent albino I knew at college, a guy who we used to call Kent the Nearly There, once told me while I was writing *Jesus died for my sins and all I got was this lousy circumcision* on an old T-shirt with a black magic marker that it was wrong for me to think of man and God as separate things. I told him that they *were* separate things, that as angry as I've ever gotten at another person, I've never been able to will locusts onto them, nor have I ever heard of God getting so shitfaced that He woke up with his scrotum superglued to the leg of a chair.

Squinting hard, his pink eyes pinched to the size of buttonholes by the light of the room, Kent the Nearly There told me that man and God were two expressions of the same thing; specifically, God was a spiritual entity that was infinitely aware and man was the corporeal projection of that spirit, minus the infinity and awareness. The analogy he gave me was that light was an expression of electromagnetic radiation and existed as an infinite property in the universe, but when it was gathered into something like a flashlight beam and aimed at a physical object, a finite shape of light appeared, and this was what humanity was: a finite expression of infinity.

"We are what God looks like projected onto flesh and bone," he said, he himself appearing pale enough to have been sculpted from a forty-watt bulb.

I responded that if this is true, for God to waste his time trying to pound enlightenment into humanity—the same way a baboon might pound on the side of a toaster because the face in the reflection looks untrustworthy—is so far beyond stupid that its distance from practical intelligence must appear to some as otherworldly and divine. Of course, what people with a mediocre understanding of intellectual physics fail to recognize, just as it is with regular physics, is that there are very strict laws of moral gravity inside the atmosphere of human consciousness, and sometimes something that appears unfathomable to a person is unfathomable because it is lying beneath our contempt and not floating high above us at the tippy-top of our idealism. After all, placed far enough away, a crucifix will look like a topless girl signaling a winning field goal, and a topless girl signaling a

winning field goal will look like all the woe and agony and bone-crushing dread of existence crammed shrieking and sunburned into a puny little unanswerable Y.

Here's what happened.

Pictured on the cover, and photographed beneath lighting severe enough to roast a hot dog, was a close-up of a vagina. It was the first one I'd ever seen so big, and with its pastrami-colored lips pried so ghoulishly wide open it looked more like a dissection of a rodent than the stuff rumored to turn a young man's fancy to snot.

All I could think when I saw it was how pissed off and ugly it appeared and how thrilled I was that it didn't look girlie. In fact, I was surprised that, belonging to a girl, it wasn't decorated with cute puffy stickers and hand-drawn hearts and the freakishly loopy signature of its owner. No, on the contrary, this vagina was cool, like a gaping wound or a ruddy little catcher's mitt, and wasn't the dainty pink indentation, cartooned and as gleefully inoffensive as a halved and pitted peach, that I remembered seeing in a book in my mother's dresser about where babies come from. No, this was something that I could imagine unhinging its jaw and swallowing an Irish setter; something that I might see in a horror movie beneath the mercurial warble of a theremin being poked at with a stick at the side of a country road by an enthusiastically ungifted actor, then WHAM!, the guy's head is gone and his girlfriend is stumbling out of the brush giggling and pulling prickers off her poodle skirt and saying, "Roger, this isn't funny! Quit horsing around—where are you?" Close-up: something that looks like a heavy breathing toupee resting in the weeds with the stem of Roger's glasses sticking out of its mouth.

Sure, I'd seen other vaginas before, but only in *Playboy* magazine; one issue, damp enough to be verging on paste, alive with beetles and worms and kept inside a shoe box and hidden inside the intestines of a rotten log in the middle of the New Jersey woods by some of my older brother's friends. And then there was a three-foot stack of issues dating back to the '50s moldering in a friend's basement amid a dead uncle's belongings, his life's ambition, according to the narrative offered by his possessions, having been to become a tournament-level masturbator and collector of beer lights and novelty cigarette lighters. Being in *Playboy* magazine, these were vaginas that were indistinguishable from eyebrows, as sexless as hamsters crunched into balls and sleeping through the afternoon. In fact, one could argue that these were vaginas in coordinates only, hidden by forearms, teddy bears, scarves,

beach balls, pillows, palms, panties, and, like the *Titanic*, by a monstrous and disfiguring lore made all the more fantastic by all the flattering invisibility that comes with a complete lack of access. *Seeing* a vagina in *Playboy* magazine was like *hearing* Vivaldi from a page of sheet music, which, when you're ten years old and your interest in girls isn't really sexual at all, is doubly frustrating because you don't have the cacophony of your own unbridled horniness to fill in all the empty space between the bull and the shit that you're trying to figure out.

And while I was fully aware of the most important fringe benefit of examining every detail of every picture of every vagina I could get my hands on, namely that to do so was a way of pressing the most vital information from a topographic map into my brain in preparation for some future hike reputed to strand and then murder those unrehearsed as to the treachery of the terrain, not even *eventual* sex was a leading motivation for my apparent need to saturate my occipital lobe with images of naked women. Instead, I was drawn in by the mythology surrounding vaginas and the fact that I saw no hard evidence that they existed in real life. To me, they suggested themselves as nothing more convincing than the bogus prize offered by the snipe hunt of postpubescence. Sure, they might appear real in books and magazines and movies, but like Roswell aliens or miniature Yeti, they were completely unsubstantiated by my experience of everyday life. I had to ask if all the praise and eye-popping mania that surrounded the female thingamajig was really just a massive delusion encoded into our DNA like the instinct, when submerged, not to inhale water; something developed genetically to deliver men into the beds of women for the sole purpose of allowing the species to continue—could it be that automated? Were erotica and pornography and iambic pentameter invented merely to assist in the cheesy Christmasification of a flabby, mundane hole at the end of a very dark alley in desperate need of some good PR? Was it the sexual variant of the famous Voltaire quote, "*If there were no* [vaginas], *it would be necessary to invent* [some]"? Certainly, a good many prisoners have been known to use the very same dictum to deflect accusations of their being homosexual while in the joint, and usually despite overwhelming evidence to the contrary, not the least of which is the tendency of paroled inmates to reenter society preferring, when handed an unpeeled banana, to eat it by drawing on it hard like a cigar.

That said, when one considers the incarceration of the whole human race within the confines of its own woefully limited consciousness, it's no wonder that the mere idea of a vagina is usually enough to trump the actual-

ity of either its presence or absence, the shortest distance between any two things being an imaginary line.

The magazine was called *Tailgunner!* and was presented to me in a clear plastic bag during fifth grade recess by a bearded eleven-year-old in mirrored sunglasses named Riviera Kamero. More disturbing about Kamero than the beard and sunglasses, always, was the overpowering scent of Brut cologne and Binaca breath spray that rose off of him like he was being overcooked by his own self-importance. That, and the whisper that he spoke in, which was the same sort that Miles Davis used at the end of his life after he'd transformed himself, with his glistening hairdos, metallic shoulder-padded jackets, and stoles of black feathers and furs, into an evil Liberace, creepy and aloof and forced to speak softly because his weirdness was already screaming its head off.

"Whoa!" I said, pulling back my hands into a classic stick-up pose. "I thought you were going to put it in a bag!"

"It *is* in a bag," insisted Kamero, his voice as quiet as the crushing of cheese puffs. "Take it."

"But that's a *plastic* bag!" I said, pushing the magazine away and looking over my shoulder to where teachers stood in a tight little circle smoking their goddamn heads off and other ten- and eleven-year-olds, at least those who weren't engaged in a fractured form of kickball or playing lightning tag, were huddled together in snarky little packs that barked and growled at passersby, uneasy carnivores of their own sparse amusements, none of them at all interested in what was being transacted a hundred yards away at the edge of the woods.

"It's still a bag," said Kamero, pushing the magazine back against my open palms.

"But you can see *everything!*" I looked him straight in the eye, seeing only myself, my black-framed glasses crooked on my face, my adolescence appearing all at once as if it were being lived amid a never-ending earthquake.

"Well, then, turn it over," he hissed, flipping the magazine to reveal, on the back cover, a picture of a pregnant woman with a black eye who was licking a cucumber.

"Look," I finally said, holding my hands out high above my shoulders and glancing down at my body, "I don't have anywhere to put it!"

"Just take the fucking thing!" he demanded, the authority of his beard and cologne and minty-fresh breath beginning to subvert my enthusiasm for our argument with the subliminal insistence that he was the adult and I

was the child. Not surprising. It was often said of Kamero that he could've passed for a smarmy thirty-five-year-old midget had his fingers been fatter and his voice been slightly more piccoloed.

"Here, give me the binder," I said, gesturing toward the dull yellow Trapper Keeper that Riviera was holding at his side, its front and back covers decorated with Wacky Packages stickers to mimic luggage labels meant to signify how well he'd traveled through *Mountain Goo*, *Blisterine*, and *Minute Lice*. "I'll put the magazine in that and then give it back to you after school."

Sighing and looking at his watch, he said, "Listen, asshole, I gotta be somewhere else." And then, as coolly as if he were cutting the string on a yo-yo that he was tired of seeing return to his hand, he dropped the magazine onto the ground in front of me and walked away. Instinctively, like a jackal having been tossed a raw cutlet just prior to the arrival of more jackals, I bent down and snatched the magazine off the dirt and shoved it up under my shirt, my eyes bugging out of my head, my ass suddenly sweaty enough to mop a poop deck.

"*Kah-marrow!*" I shout-whispered in the direction of the musky little werewolf now sauntering away, who, without turning around, offered me the ankle stone of his middle finger. Once again, I peered over my shoulder to see that no one was paying attention to me and then, turning back around to face the woods, I contemplated my next move.

Feeling as if I were attracting more attention by standing still than I would be by moving, I began walking in a casual circle with my hands folded over the bottom of my shirt to prevent the indecent exposure of what I had been forced to recognize as *my* big wet hairy vagina. As I walked I began to stoke my rage over the glaring injustice of my situation, wondering why I should be made to feel so shitty about a curiosity that I had absolutely no control over. I then thought about all the times, while standing out in the bee-saturated outfield grass during gym class, when I needed to all of a sudden scratch my ass and I wouldn't. I thought about how the itch would appear to me during the later innings of a softball game when the pitcher, usually a kid too fat or asthmatic to chase a ball, was throwing nothing but fouls and advancing runners with the thrilling alacrity of a moron dyeing a long line of Easter eggs. As the sensation intensified, so too would my contempt for the sinister intentions of a God who would deliberately de-sign a universe where scratching one's ass in public was somehow worthy of ridicule or even outright revulsion, despite the fact that it was perhaps

the quintessential example of honesty known to the animal kingdom: have an itch, scratch it. It annoyed me that such a God might be in charge of my future and that forever I'd be expected to believe that my life and the lives of everybody else around me would best be served by my refusing to recognize, much less confront, such elemental truths as an itchy ass.

In fact, it made me wonder how many other invisible strings were attached to my soul that had me favoring dishonesty over honesty. What was God trying to get away with by convincing me that restraint was somehow more virtuous than resolving something as benign as an itchy ass? And what were the chances that an itchy ass was a small truth I might need to meet head-on in order to gain access to a line of larger perhaps even cosmic truths, the walk before the run, the appetizer before the meal? Bluntly, why was it necessary for me to have to dumb myself down just because God had decided that humanity made a much better idiot than an equal? After all, an itchy ass was not open to interpretation or likely to be misconstrued. An itchy ass, in fact, represented one of the few things in the cosmos that simply *was*; recognized immediately as absolute fact without debate over its viability. An itchy ass was an incontrovertible truth, and I, by scratching it, if just for a moment, would become incontrovertibly true in my existence too, achieving what the Hindus called *Moksha* and what Jimmie J.J. Walker called *Dy-no-mite!*

Likewise, with the vagina beneath my shirt, there was also an excruciatingly annoying itch, an intellectual one, that I wanted to scratch, but for similarly mysterious reasons I refused to lay a finger on it. Why?! The way I figured it, if it was true that such a thing as a vagina even existed in the real world, which I still had my doubts about, and if it was a thing that could be examined up close, have its anatomy explained by a sober mind and its function ferreted out and understood by both the science and entertainment communities, then wouldn't this automatically mean that any perceived threat to civilization one might imagine it posed had to be mythology at best, pandemic brainwashing at worst? Did not the discovery of the man behind the curtain in *The Wizard of Oz* forever shatter the illusion for the Ozonians that they needed to cower at the sight of their leader's huge, disembodied, and flame-retardant head? Conversely, if a vagina *didn't* exist in the real world and if all the genuflecting over its fanciful depiction in magazines and folklore was nothing but superstitious hooey, then shouldn't *that* be enough to obliterate the power of its black magic? Indeed, was it not true that mankind, throughout history, has slaughtered many more monsters

by installing nightlights than by gathering together all the pitchforks and torches in town?

The question stopped me from pacing and had me take the copy of *Tailgunner!* out from under my shirt and stare into the yowling void on the cover and wonder if I was looking into the face of Frankenstein's monster. Figuring that not every house was wired with electricity and that a nightlight needed an outlet to enlighten, I wondered if my fury had less to do with the so-called superior intelligence of God failing me and more to do with the inferior intelligence of society excluding me. Feeling that my anxiety over needing to scratch my ass or being caught with a picture of a ginormous pussy was an anxiety that had more to do with being afraid of impending mob violence than some abstract notion of eternal damnation. After all, assuming that God was all-seeing and all-knowing and all-complaining, had He not heard my thoughts contemplating how awesome it would be to scratch my ass in public, and had He not seen the vagina in my hands and been bombarded by my telepathy informing him how driven I was to mentally yank every one from every page of every pornographic magazine I could get my hands on and stack them up in my brain and dance and yippie around them until my feet bled, and had He not shrugged His big goofy shoulders and just walked away with other fish to ignore or to fry?

Perhaps that's why being pissed off at God as an act of defiance never seemed to provide any relief whatsoever to my everyday annoyances over either the mechanical failings or existential shortcomings of His shitty Creation and required no bravery at all. Perhaps all I was doing with such defiance was personalizing my own aggravations about the world and then disassociating myself from them and then giving them a white beard and a baritone voice that I could attempt to threaten or guilt into accommodating my mood or bending to my will, essentially creating a happy-go-lucky yin to complement my cankered yang. Perhaps I was modeling God after a person because I knew deep down that people, not divinity, were the mismanagers of Providence and, true to the tragedy of the situation, I was one of them. I imagined God looking down on the streets of Salem in 1692 and knowing that epilepsy and demon possession are never synonymous with one another, but rather than grabbing a bullhorn and clearing His throat and using His wisdom to piss all over our freshly struck matches, He left it up to us to concoct our own logic and build our own Eden and exact our own concept of justice upon our accused. I saw myself, then, using a water pistol to stand outside and blast holes in the rain while, beneath the loving shelter of a tril-

lion umbrellas, my sister and mother were burned alive for menstruating on a Sunday.

Watching the magazine frisbee into the weeds in front of me at the ringing of the recess bell, I turned and headed into the rest of my life, the frown on my face suggesting to the world that my head must be on upside down, when really it was just my brain that was inverted, its perspective revealing Heaven to be the Hell that gravity forced all of humanity to stand upon.

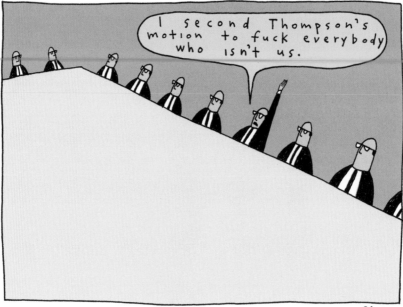

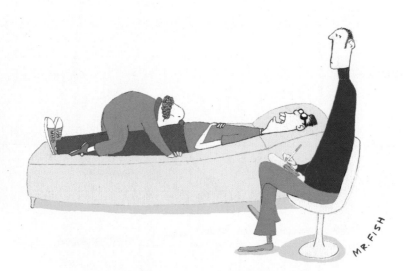

"I don't dread telling my parents that I'm gay half as much as I dread introducing them to the clown."

A candidate is an asshole who will seek to convince the public that he or she is a hero when compared to other assholes.

MR.FISH

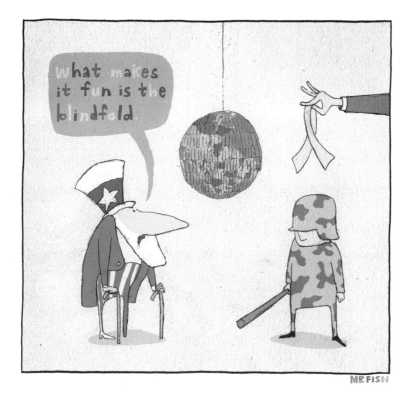

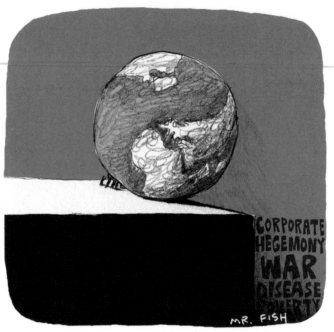

G8 leaders hoping to remedy the environmental crisis by moving the planet 3 degrees away from the sun.

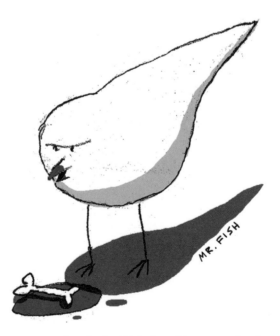

"Wow - I never thought that I'd find anything to eat after they took olive branches off the menu."

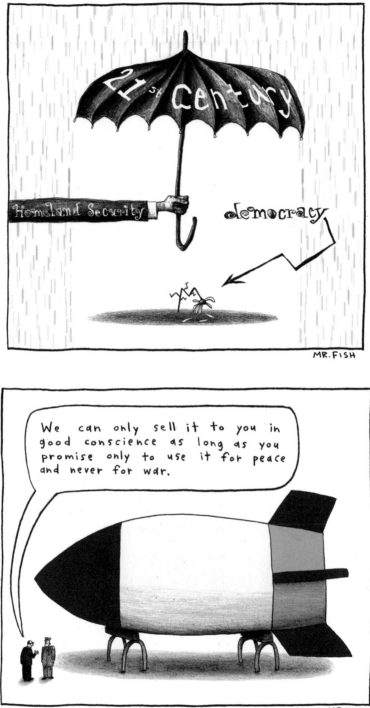

AT THE WHITE HOUSE, PRESIDENT BUSH COMMEMORATES
BLACK HISTORY MONTH WITH A SLIDE SHOW OF PICTURES
HE TOOK WHILE FLYING OVER NEW ORLEANS LAST SUMMER.

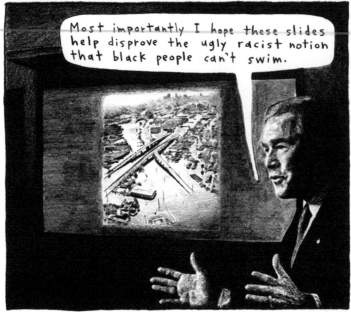

Most importantly I hope these slides help disprove the ugly racist notion that black people can't swim.

MR. FISH

COLIN POWELL RE-ENTERING THE JOB MARKET.

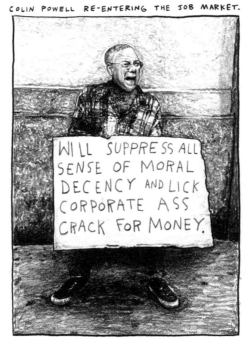

WILL SUPPRESS ALL SENSE OF MORAL DECENCY AND LICK CORPORATE ASS CRACK FOR MONEY.

MR. FISH

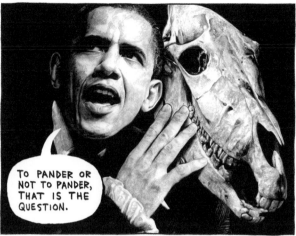

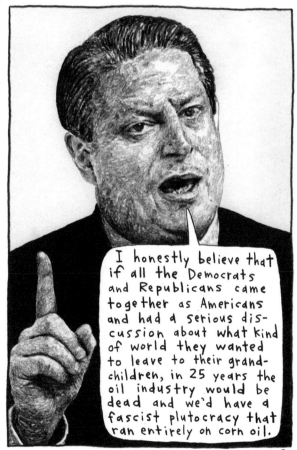

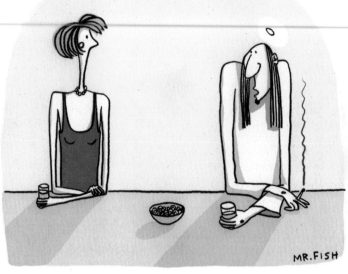

"My dad invented the beaver."

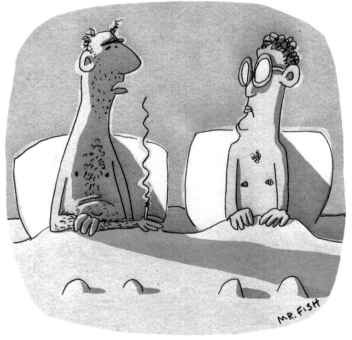

"I'm fine with the role-playing, really. It's just that if I'm Joe America and you're Wall Street, then shouldn't I be the one who gets the safeword?"

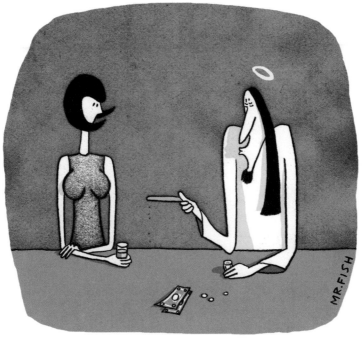

"And see if you can guess what this bread stick represents."

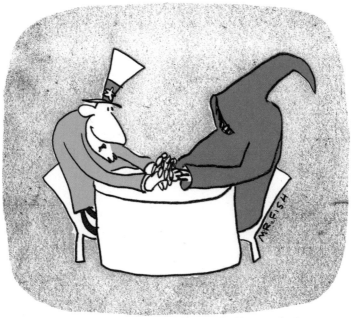

"I think, for the sake of the children, we should stay together."

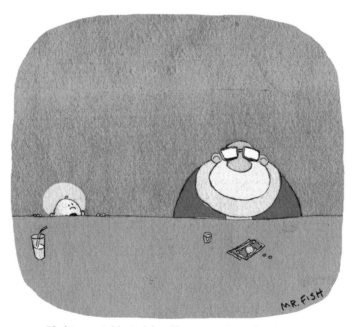

"So let me get this straight, old man - you're saying that all I
have to do is renounce my Judaism and everybody will like
me more?"

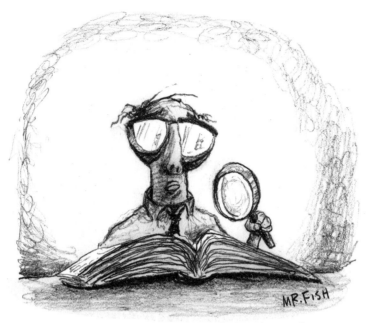

*Fearing the complete collapse of Western Civilization and not wanting to
deter America from its mission of love in the Middle East, Wendell decided
to keep quiet about his discovery that Jesus Christ didn't, in fact, die for our
sins, but rather he died BECAUSE of them.*

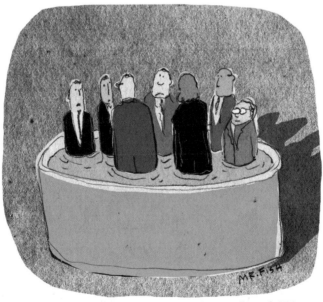

*"So, as the leading industrial nations of the world, we're all agreed: We're
going to limit the amount of peeing we do in the pool so that soon all the
fish will come back."*

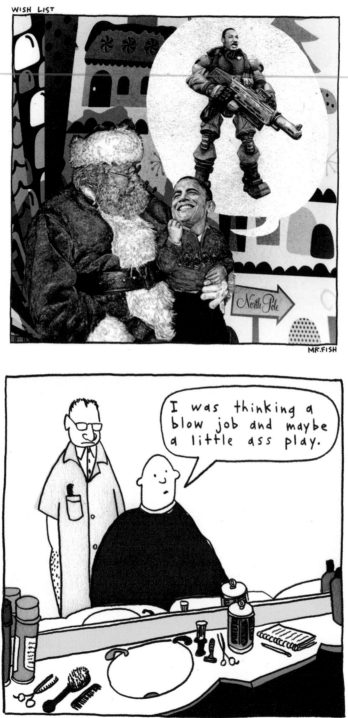

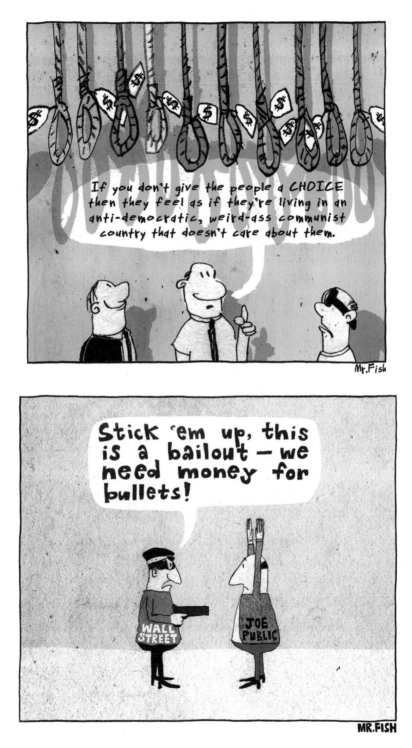

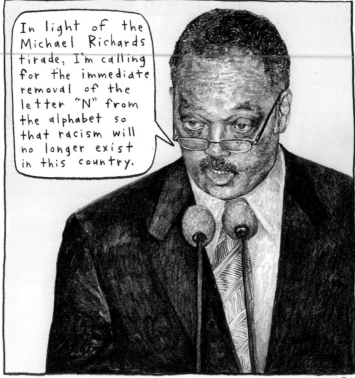

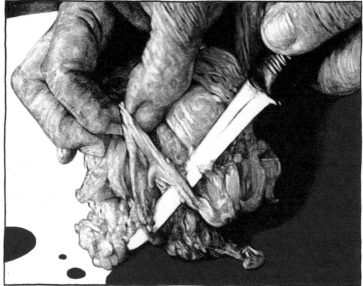

IT IS TIME TO RECONSIDER THE PROCESS BY WHICH WE GATHER OUR WISHBONES FROM OUR DOVES AND TO KNOW PRECISELY WHAT WE'RE DOING TO OUR OWN MORAL JUDGMENT IN OUR QUEST FOR PEACE.

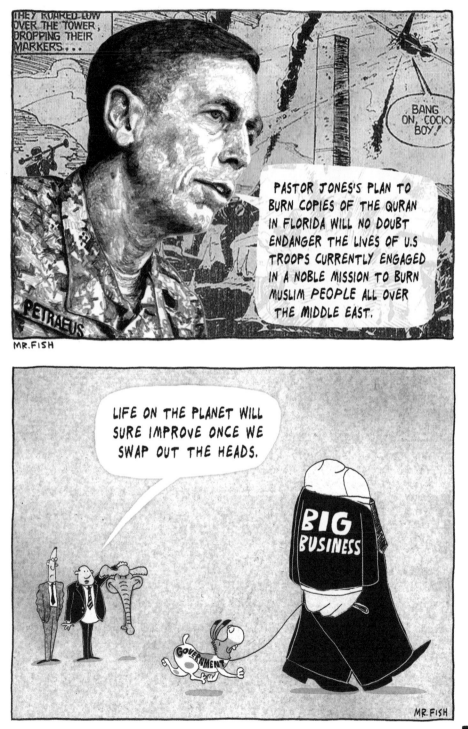

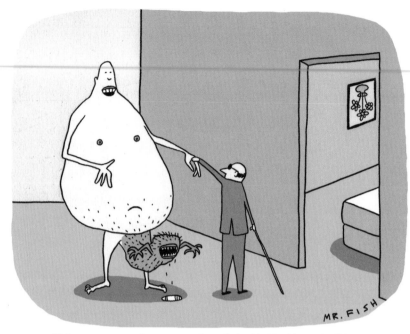

"Before we move on to the next stage of our relationship, Harold, you should know that I'm flat-chested."

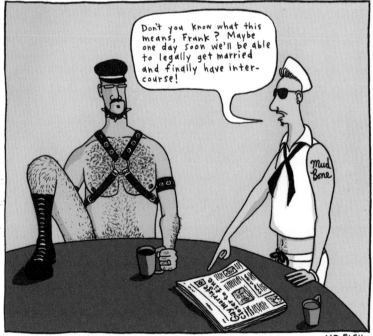

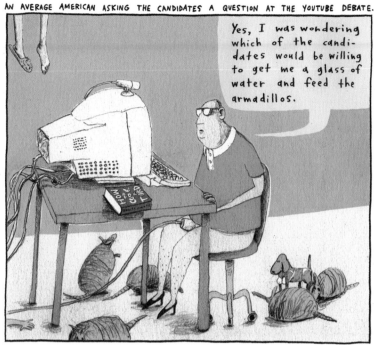

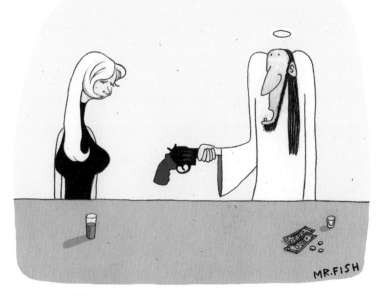

"You want to come up and see my etchings?"

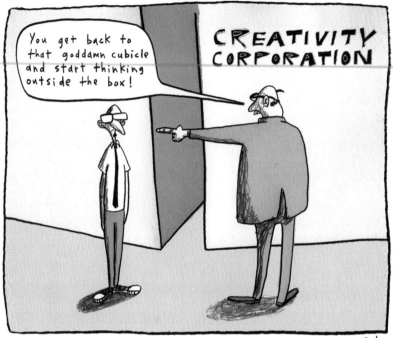

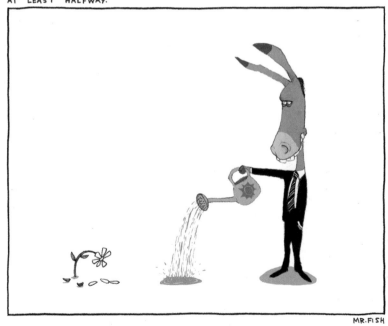

THE DEMOCRATIC PARTY PROVING ITS MORAL SUPERIORITY OVER THE REPUBLICAN PARTY BY MEETING THE NEEDS OF THE PEACE MOVEMENT AT LEAST HALFWAY.

WWSD?

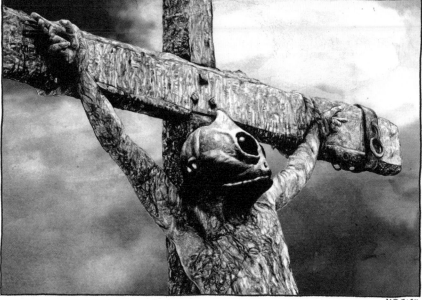

THE PATERSONS DOING THEIR BEST TO MAKE THEIR DAUGHTER'S HOMESCHOOLING AN AUTHENTIC EDUCATIONAL EXPERIENCE.

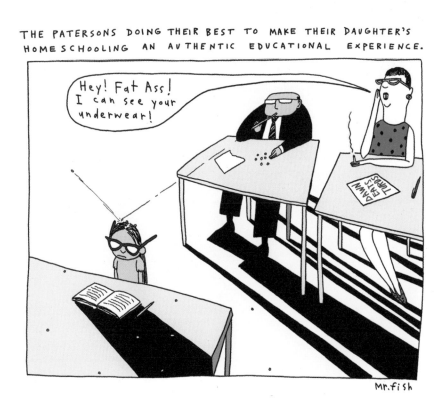

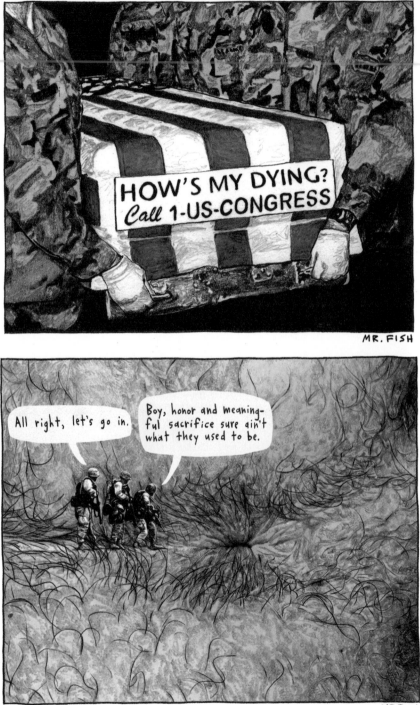

ALL OF A SUDDEN, JESUS AND THE FAT CAT APPEARED BEFORE THE FORLORN
AND WANTING SAND NEGROES TO EXPLAIN HOW RAPE WASN'T REALLY RAPE IF
THE RESULTING BASTARD WAS NAMED "DEMOCRACY" AND THE SAND NEGROES
WERE SO THANKFUL AND THEY JUMPED FOR JOY TO KNOW THAT AFTER ONLY
A FEW DECADES OF HORRIBLE PAIN AND SOUL-CRUSHING HUMILIATION THEY'D
GET TO LIVE HAPPILY EVER AFTER...

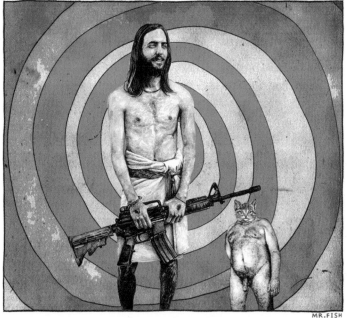

GEORGE BUSH IN THE OVAL OFFICE WATCHING KARL ROVE LEAVE THE WHITE HOUSE.

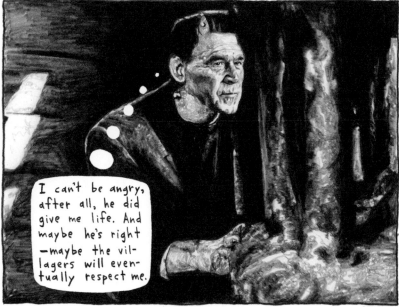

117

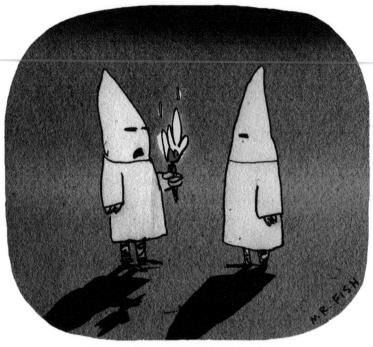

"Now remember – whatever you do, don't use any racial epithets. We don't want any trouble."

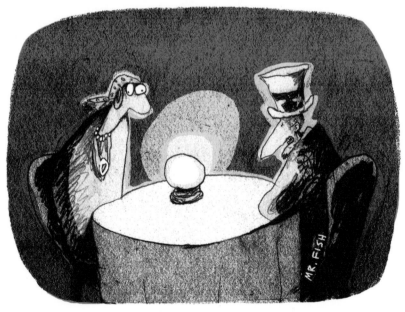

"I'm not sure that 'Nothing but the same shit' really consititutes a 'reading.'"

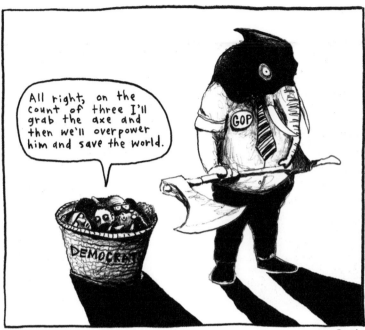

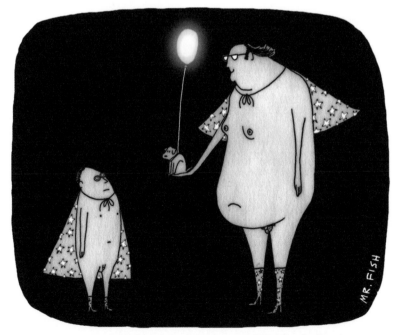

*Adam congratulating his son for perpetuating good Christian family values
by marrying his little sister and then knocking her up.*

Vern trying to decide if he is a Democrat or a Republican.

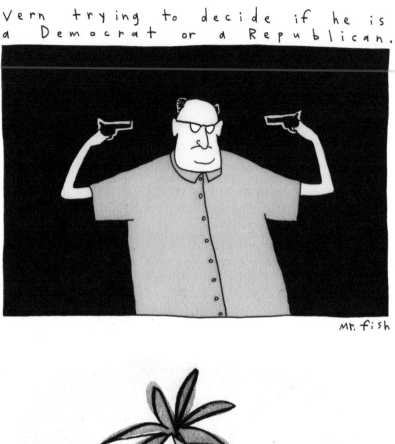

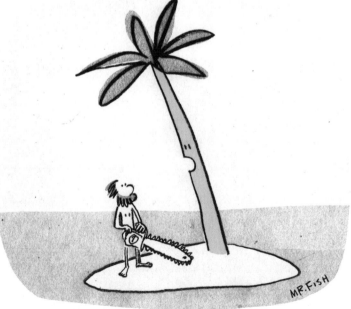

"Alright, you crazy motherfucker, let me get this straight – you're committed to a two state solution, but you need to build a security wall out of wood to make it work?!"

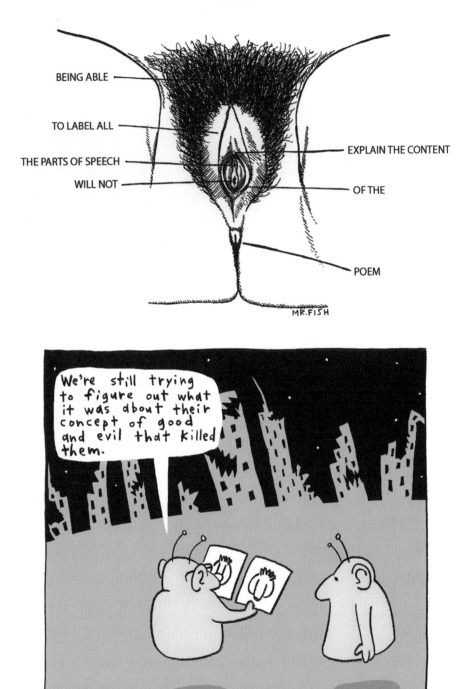

GOD'S TOP TRANSLATOR MEETING WITH ALLAH'S TOP TRANSLATOR TO DISCUSS THE FUTURE POSSIBILITIES OF WORLD PEACE.

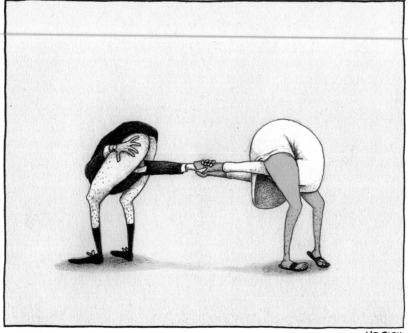

MR.FISH

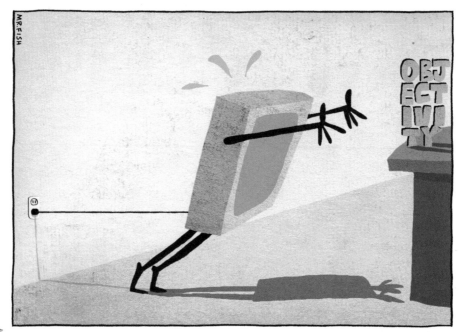

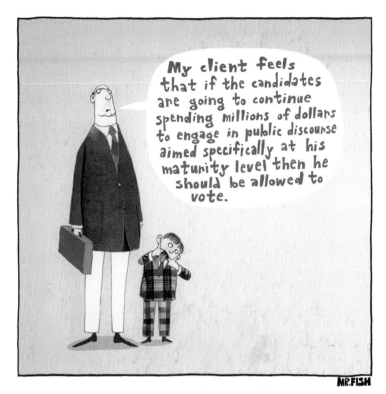

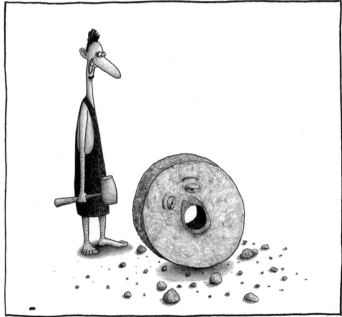

BARACK OBAMA SELLING HIS WAR IN AFGHANISTAN TO SUCKERS.

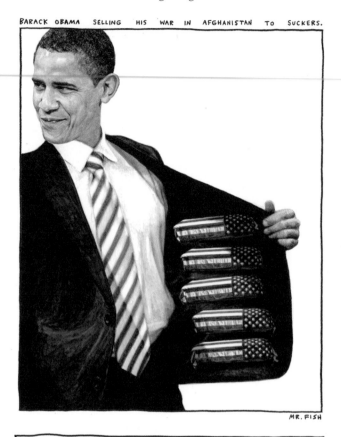

MR. FISH

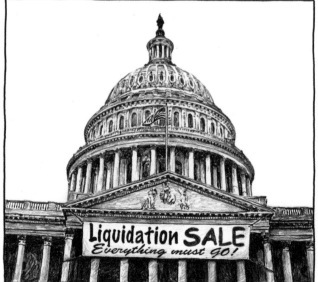

MR. FISH

PRESIDENT BUSH SHOWING VASTOR HOLLOWAY III, AGE 9, HOW THE COMPLETE MORAL AND FISCAL BANKRUPTCY OF THE UNITED STATES OF AMERICA AND THE DASHING OF ALL THE HOPES AND DREAMS FOR PEACE AND PROSPERITY OF FUTURE GENERATIONS MAKES PERFECT SENSE ON PAPER.

MR.FISH

COLIN POWELL BEING CALLED OUT OF RETIREMENT TO, ONCE AGAIN, GIVE DIRECTION TO AN EMPIRE FOUNDERING ON THE SPLINTERED MULTIPLICITY OF ITS OWN HUBRISTIC BOREDOM.

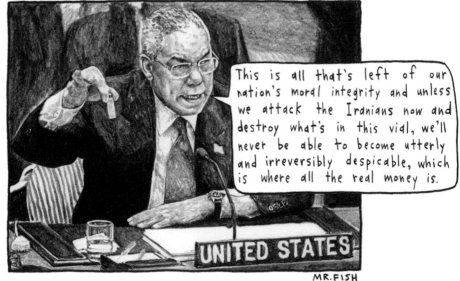

This is all that's left of our nation's moral integrity and unless we attack the Iranians now and destroy what's in this vial, we'll never be able to become utterly and irreversibly despicable, which is where all the real money is.

MR.FISH

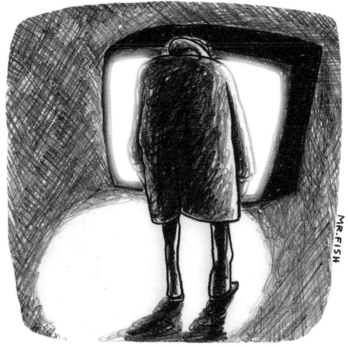

God watching the 24 hour news cycle and deciding he is an atheist.

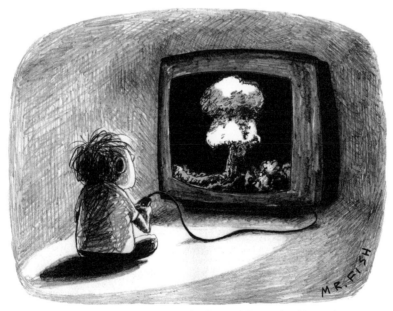

Max being conditioned to experience the ultimate failure as the ultimate victory.

"I know you're not gay, private – I'm talking about the 'Don't Ask, Don't Tell' policy regarding you being a homicidal automaton - that's what our democracy demands that we keep in the closet."

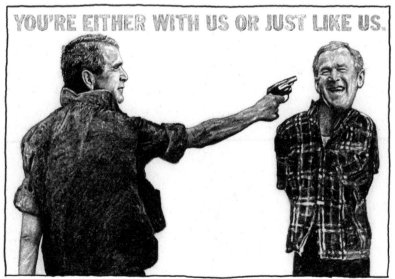

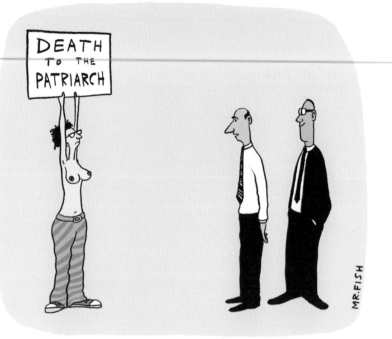

"She really does make a good point."

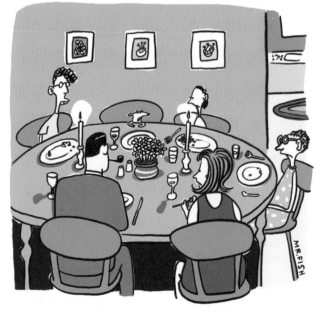

*"I'm warning you, young lady! You refuse to eat your vegetables again
and I'll stop having sex with the dog!"*

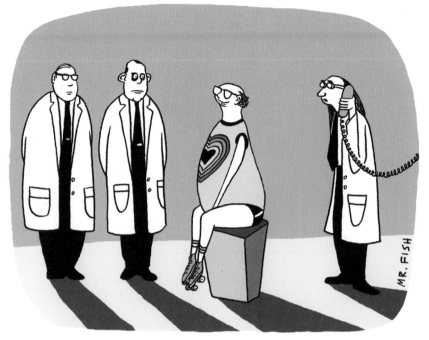

"They say let him go – apparently, he's not the only gay Gene."

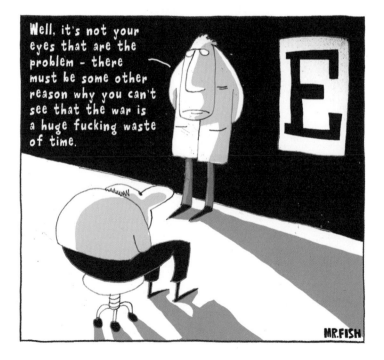

131

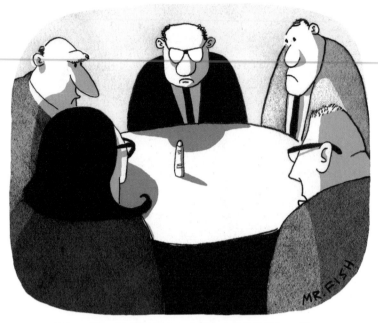

"Before we throw a ton of money into constructing a tomb for the Unknown Finger we should first determine if it's saying 'Fuck You!' or 'We're Number One!'"

MRS. NEFF FIGURING OUT HOW TO GET AROUND THE OBAMA ADMINISTRATION'S PIDDLING 3 BILLION DOLLAR INCREASE FOR EDUCATION BY TAPPING INTO THE 708 BILLION DOLLAR MILITARY BUDGET.

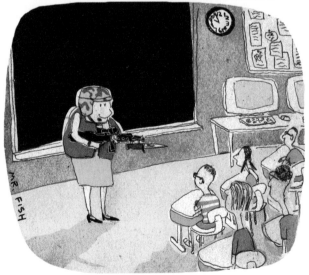

"We can keep the upgraded computers and the new reading lab if, every few days, I kill at least one of you."

132

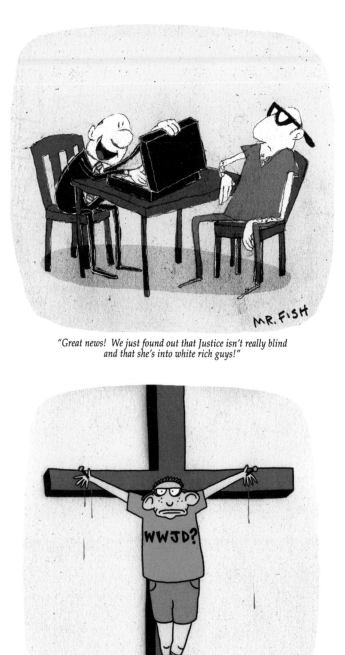

*"Great news! We just found out that Justice isn't really blind
and that she's into white rich guys!"*

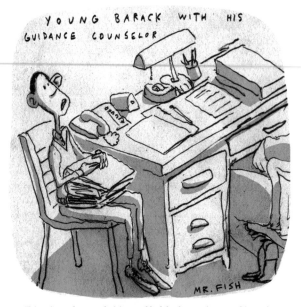

"It's going to be your decision – a black leader requires moral integrity and a black politician does not."

Reggie entering his 38th week of trying to come up with the emoticon that means, 'The oozing sores that I have on my ass from sitting so fucking long in front of this computer are starting to smell like old salad dressing and if I don't have an actual conversation with a real human being soon, one where I can see the person's actual face and hear his actual voice, I'm going to tear down my spam and virus firewalls and let the worms and bots and Trojans devour all that makes me fascinating.'

"Dear Mr. Spam Filter...I don't want a bigger
penis - I just want a smaller world..."

"No, really, the sex is fucking awesome and I'd marry her tomorrow if she
wasn't such a goddamn Jesus freak."

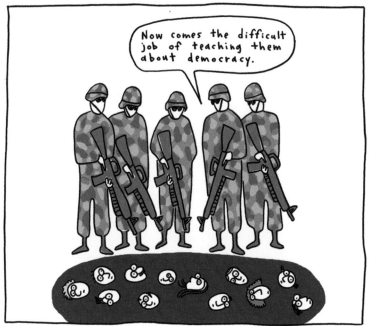

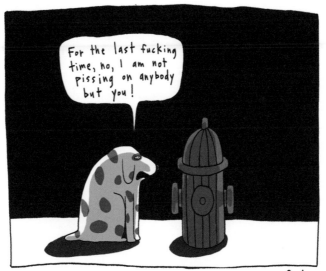

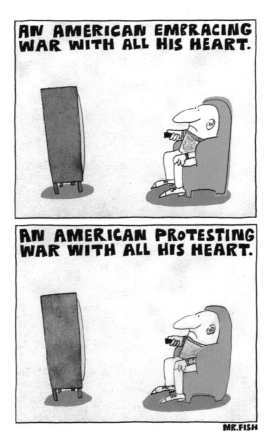

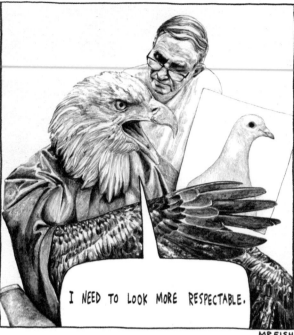

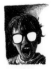

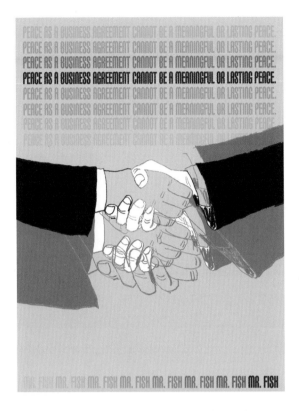

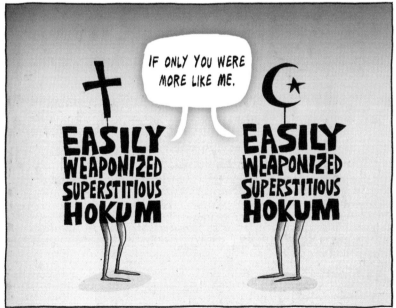

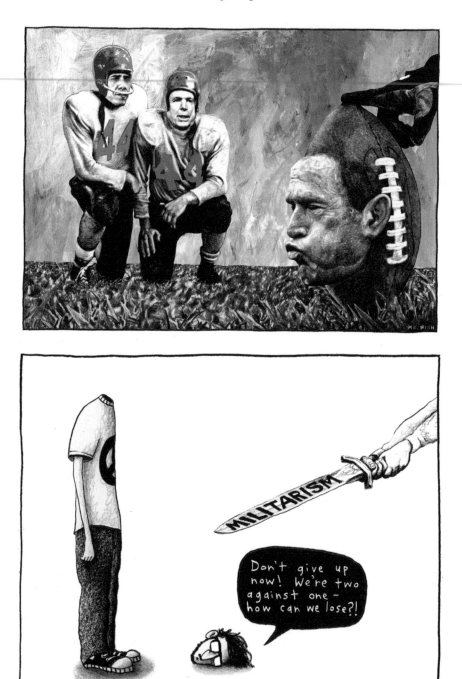

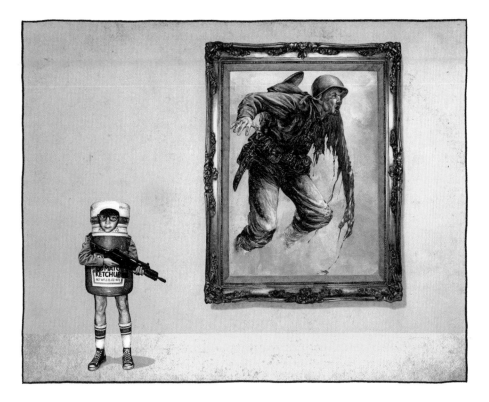

Anger

Time exists in order that everything doesn't happen all at once . . .
space exists so that it doesn't all happen to you.
—Susan Sontag

Iused to love getting killed when I played war as a kid. I would crawl around on my belly with leaves and sticks stuffed into the green camo netting stretched over my army helmet, my rifle being dragged along for show, as lethal as a rake, until I found a nice patch of grass or dead pine needles where I would stand up and get my head blown off, my fictional brains exploding through my shooter's imagination like so much ghoulish creamed corn, and then I'd collapse and just lay there, looking up at the sky

through the trees. In the surrounding woods I'd hear my big brother Jeff and his friends take turns yelling "*POW!*" and "*BANG!*" at each other in between long silences. And then there'd be the debates over the severity of the conceptual injuries and whether or not they were fatal. There'd be some name-calling and some pushing and shoving, maybe followed by a fistfight where real blood would be spilled. Sometimes I'd even fall asleep.

I guess that's when I first started to realize that I preferred dissent to aligning myself with a group, *any* group, deciding that reality by committee never seemed to produce anything but an aggravating consensus of split differences, a splintered and compromised vision of things, which was never wholly satisfying to anybody at all. No big surprise. Asking any group of people to voice their common concerns or to unify their purpose always requires that they first learn to bowdlerize their individuality and curb their unique, potentially contentious perspectives in favor of reaching a consensus designed to approximate a foggy notion of the truth, one that is most accommodating to everybody involved. For that reason alone, the communal consciousness is a very bland soup indeed, so inclusive and so tolerable and so generic in its design as to avoid being very tasty, all subtlety and attention to precise detail abandoned and replaced with only the largest chunks of basic, consensual information. It is human consciousness itself dumbed down and fed through the synthetic colon of a fastidious public relations firm, neutered and perfumed to prevent upsetting or marginalizing anybody confused by the messy multiplicity of life—not that I have ever been against compromise or consensus-building. But when I was a kid I needed the plateau of fact, upon which everyone had agreed to congregate, to be about something other than the macabre and predictable virtues of living and dying by the real or imaginary sword.

Not so for my older brother. At eleven, wearing my grandfather's flak jacket and helmet straight from the Second World War and carrying the Arisaka Japanese Type 99 rifle that Granddad brought back with him in 1945, my brother, palsied by so much heavy equipment and authenticity, felt that dying, even pretend dying, might dishonor our grandfather's very real sacrifice, which we all assumed had to be significant since he refused to ever talk about anything that went on during war, never mind recounting it as a great adventure. The one story he begrudgingly told my older brother, who then told it to me while we were laying in the dark in our bunk beds beneath adhesive stars, was about how our grandfather's unit once found a German soldier hiding in a tiny bunker. It happened at night, in the middle of win-

ter somewhere in the French countryside where members of the Resistance had dug out these holes beneath haystacks for the purpose of providing safe havens for Allied soldiers and airmen trapped behind enemy lines. The German soldier was startled and drinking hot tea when he was discovered and, apparently, wasn't allowed to finish his cup, a detail that struck me as being profoundly sad. No wonder any mention of the war always seemed to make our grandfather miserable and quiet, I thought, and I imagined a filthy tin cup full of tea bouncing off the frozen ground and a pair of freshly dead eyes looking up into a perfectly holy, star-filled sky.

During the summer days when my brother and I were alone in the woods, digging foxholes or distributing the cracked golf balls that we'd pulled from the lake near the country club not half a mile from our house and tossing them into existing foxholes to be used as hand grenades during our next great battle to eradicate boredom from the sweltering afternoons with our friends, we talked about how well we planned on holding up under both captivity and torture from the invading army that we were sure to encounter as full-grown men. We talked about how important it was to practice, while riding on the bus to school in the morning or waiting to fall asleep at night, the skill of tongue swallowing, a talent we hoped to have at the ready just in case our interrogators happened to carve out an exploitable vulnerability in our resolve and get at top-secret information. We rehearsed the concept of selflessness over and over again inside our own heads in preparation for the day when we'd have to throw ourselves upon the enemy hand grenade that got lobbed into the center of our future platoon, which would be battle weary and lovable and appropriately moved when picking up the bite-sized pieces of us for burial in Arlington. We wondered aloud what we would do, as imprisoned GIs, if sent down the steep slope of an impossibly long slide of razorblades—would we attempt to go down on our hands and knees in the hopes of halting our descent by trapping the razors in our kneecaps, or would we lay down and press the backs of our necks hard into the blades hoping to sever our spinal cords, thereby making us impervious to the agony of our mutilation? We wondered what being killed in an oven would be like, whether we'd be thrown into one that was already hot or if we'd be placed into a cold one and then have the heat turned on while we struggled inside and shrieked and pounded on the blistering metal of the locked door. Would we be all alone or in a group? Would we pray? Would we cry? Would we be heroes?

Years later, I found myself sitting in a posh New York City hotel lobby

beneath an immense chandelier dripping with Lucite diamonds, recounting in vivid detail all the preadolescent war preparedness I'd exercised as an all-American boy to Tariq Ali, world-renowned peace and social justice activist, commentator, novelist, filmmaker, and friend to John Lennon and Mick Jagger and others who helped establish the 1960s radical antiwar youth movement in swinging London. In fact, it was he for whom Jagger penned "Street Fighting Man" and who inspired Lennon's "Power to the People." (He's also the guy who turned on a whole new generation of young antiestablishmentarians during the early years of the second Bush administration by participating in a debate tour with formerly left-leaning comrade Christopher Hitchens, who, in an apparent about-face, ended up supporting the U.S. invasion of Iraq and Afghanistan and who saw some crazy wisdom in the president's chuckleheaded imperialism and who, for months before college audiences and progressive forums, sneered and flipped the bird at his detractors while Ali, with grace and elegance and well-reasoned rage, tore his old colleague a new asshole—a new asshole, that is, into which Hitchens could megaphone his intellectual buffoonery, making it sound authoritarian and Chuck Heston–like, for those at the back of the packed auditorium who might be hard of bleating.)

"When you were growing up in Pakistan," I asked Tariq, "did you and your friends ever play war and talk about what your enemies might do to you if you ever got captured?" Looking at me as if I'd just asked him if he and his friends had ever eaten glass, he told me that most of the conversations that he and his buddies had as kids were about cricket and football. War, according to him, was more a horrifying catastrophe that misguided grown-ups occasionally fell into and not a game that children organized with great enthusiasm or that they felt they needed to anticipate with absolute certainty. "Probably gives you some insight as to why so many Americans constantly misread the savage brutality of the U.S. military as heroism," I said.

"I was in North Vietnam in 1967," replied Tariq, pitching forward to rest his elbows on his knees and speak lyrically through his magnificent gunmetal-gray mustache, "and I'd heard about this American pilot, who turned out to be John McCain, who had been shot down and pulled from a lake, and I remember very distinctly asking the Vietnamese how these captured airmen, after inflicting such misery on the country and causing so much human suffering, how was it possible that they were not killed on the spot by those who found them?" He was told that the people of Vietnam were very disciplined and that, simply, they were told not to tear the downed pilots limb

from limb. Beat the absolute shit out of them, fine, but don't kill them. I sat back in my chair and wondered if I'd be heroic enough to exercise restraint if placed in the same situation as the Vietnamese. There's me and my destitute family, barefoot and wanting, living in a country completely wrecked by decades of French occupation and then U.S. invasion, and there's John McCain flying above me in an A-4E Skyhawk fighter plane under orders from the richest and most powerful nation on earth to revile my desire for independence and to crave, bug-eyed and all sloppy-tongued, my annihilation. Attacking me from such an altitude as to be nearly impervious to retaliation and using technologies a hundred years beyond what I'm capable of responding with, he is proceeding with his mission from a position of relative invincibility, making him a torturer and me the poor sap screwed inside the iron maiden into which his government orders him to thrust his bloodlust. He and his fellow flyers have already killed millions—yes, *millions*—of my neighbors and family members with bullets and bombs and cigarette lighters and jellied gasoline, and neither he nor his pals show any signs of suddenly developing a moral conscience that might convince them to cease and desist. Now there's John McCain in the lake, no longer able to murder me and my friends and family. Gee, I can't wait to say hello to him. I've never met a real hero before.

Buoyed by the glee of nay-saying with Ali and finding fault with so many and so much—state-sponsored hypocrisy being such a deep and giving well from which to draw—I thought back to the beginning of the 2008 presidential election and an interview that I did with Dennis Kucinich, congressman from Ohio, who, like McCain, was then running for the presidency. Unlike McCain, Kucinich was a pacifist and campaigning on a platform that was demanding total and immediate withdrawal from Iraq. "You refer to our presence in Iraq as an illegal occupation," I'd said into my cell phone, notebook on my knee, having been denied a previously promised drive-along interview with the congressman on his way to the airport, so that my question was coming to him from the car directly behind him on the highway.

"Right," answered Kucinich into his cell phone, clearly annoyed as hell.

"If our presence in Iraq is an illegal occupation," I continued, "then doesn't that automatically mean that our mission as occupiers is criminal and that those actively engaged in the actual occupying are criminals?"

"Those aren't my words! Those aren't my words!" he shouted, as if I were attempting to fit something reprehensible into his mouth, rather than merely sliding a cylindrical shape into a cylindrical hole.

"I know! I know!" I said. "I'm just asking a question."

"What's your question?" asked the peace candidate with steam coming out of his ears.

"My question is this: Is it possible to have an army of good guys when their combined efforts contribute to the perpetration of a massive crime against the population of another country? Wouldn't that make them bad guys? How can we support the troops and call them heroes when we abhor what their duty requires them to do?" Nothing. "How can we support the wick of a candle and not the flame?" Nothing, again. "Isn't that a little bit like supporting the word *motherfucker* and being against the obscenity?" That was it. He hung up. Interview over.

"Unbelievable," said Tariq when I told him this, running his hand over his great mop of silver Beethovenesque hair. "Absolutely surreal—I hope you're going to write about that."

I said that I was and that such white-knuckled loyalty to dull and patriotic bullshit, particularly by a man you might assume should know better, reminded me of an asinine metaphor spoken by peace-mongering ex-Marine and UN weapons inspector Scott Ritter at a talk he'd given just a week before my meeting with Kucinich. "When you go to war as a soldier, the debate's over," he'd said, standing on a dilapidated stage in a crappy playhouse at the edge of L.A. dressed as an insurance salesman on his day off, his tiny haircut clamped hard to the top his head, his mien as commanding as Ivory soap. "You've been given a lawful order and you're doing your job—you're not in combat to debate the constitutionality of the act of fighting. War is the fire that we all hate and the brave men and women in uniform are the innocent firefighters who we all love, end of story." *What does it mean, though, when the architects of the war only issue flamethrowers for the troops to fight with?* That's what I wanted to shout, but I chickened out. Instead, I waited until he was done speaking and applauded along with everybody else, saddened by my own moral cowardice.

Dig.

After I blew the tip of my finger off with a pellet gun at the age of twelve and found myself sitting in a wheelchair in a hospital corridor wearing my twin sister's sweater, I decided that it was time to swear off guns. With my hair down to my shoulders and waiting to have my hand X-rayed—too embarrassed to make eye contact with Corbin McPhee, a classmate of mine who had a crew cut and who was manly enough at twelve to have pimples on his back and a mustache and who was sitting next to me in his own wheelchair and holding an ice pack against his massive shoulder and still

wearing his wrestling singlet, having come straight from a match, his junk as clearly defined as a helmeted woodchuck in a sling, his armpits like halved onions emitting a BO that rung loudly enough to hurt my ears and vibrate my fillings—I said to myself, *No, really, this is it, I'm a pacifist from here on out, no more fucking machismo for me. Enough is enough.*

I figured that transitioning to a nonviolent lifestyle would be a breeze, having already spent the first year and a half of middle school completely blind while moving cautiously through the hallways in between classes because I was afraid of my reaction to the daily fistfights that would always spontaneously erupt, it seemed, right in front of me. I'd be sitting in class, the bell would ring, I'd shove my crap into my backpack, walk into the hallway, and a guy would hurl himself through the crowd and crack his fist into somebody else's face about five feet from where I stood, and I'd let out a high-pitched yelp like a cocker spaniel and cover my mouth. I couldn't help it. It was completely involuntary. When I noticed that I was the only one who cried out and didn't start chanting *"Fight! Flight! Fight!"* while simultaneously rushing closer to the grunting tornado of swinging fists, I took to removing my glasses before shoving my crap into my backpack and stepping into the hallway. No longer able to express empathy for my fellow man, simply because I could no longer *recognize* my fellow man's suffering, I was able to experience the profound satisfaction that comes with being part of a community. Blurry eyes crossed and seeing nothing, I'd say *"Fight! Flight! Fight!"* and count down the days to graduation, which was when I planned to run like hell for the hills without looking back.

Gazing down at my gauzed and pulsating bloody hand, which looked like a hornet's nest oozing cranberry juice, it annoyed me to remember how I'd pestered my parents for months for a pellet gun for Christmas, insisting that I was a lot more mature than my older brother who was always having his BB gun confiscated for shooting birds and grasshoppers *and* his friend Richie—who cared if Richie asked him to do it? Richie was an asshole. Hands clasped in literal prayer, I swore to my mother that if Santa Claus, the yuletide gunrunner who'd given my brother his weapon, brought me a rifle, I'd restrict my marksmanship to paper targets and the bald-headed naked-lady mannequin that my grandmother had pulled out of the trash behind a department store and driven down from Pennsylvania in the back of her station wagon so that I could shoot it full of arrows using the compound bow I'd gotten for my birthday.

Five days after I got the gun, which turned out to be powerful enough

to shoot through nickels, I was alone in the backyard blasting away at the mannequin, who we called Yul Brenda, when my friend, also named Richie, showed up with amber snot bubbling out of his nose and a laugh hysterical enough to cripple his posture and zigzag his approach. (My Richie was a bit of an asshole too.) In response to his cackling request, and against my better judgment, I handed him the gun and noticed that he was laughing so hard that he couldn't aim straight. At one point he even pressed the muzzle against my forehead. Then he admitted that he'd just taken his first hit of acid, saying, "I can see the, whaddaya call it, trajectory of each bullet as it flies, bro—and they're all different colors, the lines . . . Can't you see them?!" Worried where a fascination with kaleidoscopic trajectories might lead a person, I took the gun from him without noticing that it was still loaded and slid it into its rifle bag and went back inside.

The next day, anxious to get outside so that I wouldn't miss my brother flying over the house in a single-engine airplane with a fellow Boy Scout and their scoutmaster who had a pilot's license, I quickly grabbed my twin sister's sweater from the top of the dryer and put it on, figuring I'd only be out there for about ten minutes. Then I grabbed my gun, slid it out of its sheath hoping that I'd be able to pull off a few shots before the plane buzzed by, and, looking around for my shoes, cocked the hammer, compressing CO_2 into the firing chamber, set the muzzle against the center of my left index finger, and pulled the trigger, expecting to feel that cold snap of air I'd come to absentmindedly love.

Then the tip of my finger was on the wall. Then I was on my way to the emergency room with blood dripping onto my pants and my stepfather yelling at me, his face completely drained of color as he drove. "If anybody asks, you fell out of a tree!" he shouted.

"I what?"

"You fell out of a stinkin' tree! Understand?!"

Then came me moving from room to room at the hospital in a cream-colored sweater covered with tiny daisies and having different doctors take turns pulling the chart off the back of my wheelchair and wearily asking the attending nurse, "What's the matter with her?"

"*He* fell out of a tree," the nurse would say. Then the doctor would read the triage notes to himself and they'd both laugh. Even the surgeon assigned to sew me up at the end of the night closed my file with a chuckle and, noticing my sweater, asked, "You want to change that to a shark attack while I have my pen out, princess?"

Laying in bed that night with my finger throbbing in its splint and the adhesive stars on my ceiling having long since been obliterated by two coats of paint, I came to realize that death is a motherfucker, and not just because it kills people and makes us sad. What sucks most about it is that it can dilute the truth about the dead person's life by reducing all the facts about him or her to rumor and opinion and secondhand interpretation. Like with my grandfather, and probably the majority of soldiers who either survive or don't survive war. When injuries and tortured psyches are no longer an actual presence, pain can become mythologized and made noble, and the horrible circumstances that hobble men's souls can be forgiven or forgotten. While my grandfather was alive there was something exhausting and unforgivable and, frankly, infuriating about how his depression and alcoholism and PTSD could sometimes dull his otherwise quick wit, the wisdom in his piercing blue eyes, and his absolutely heartwarming approachability. Dead, he is an angel. He is unbroken and self-sufficient and in no need of human companionship or the camaraderie of meat. He is healed. Dead, his virtues are missed and remembered over his failings, which disappear because they comfort no one. Dead, he is elegant and charming, his presence as dainty as absence.

All alone in my bedroom and feeling the weight and heat of my body pressing down upon my mattress in the dark, I wondered if the new antiwar me would have the decency to accept the stupidity of my former tongue-swallowing, gun-loving self by either remembering him with grace and humility or forgetting him with rage and malice. Either way, I couldn't decide if I was jealous of the buried dead or thankful for the broken heart that corroborated the virtue of the peace they enjoyed.

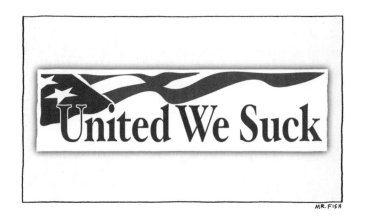

MR. FISH

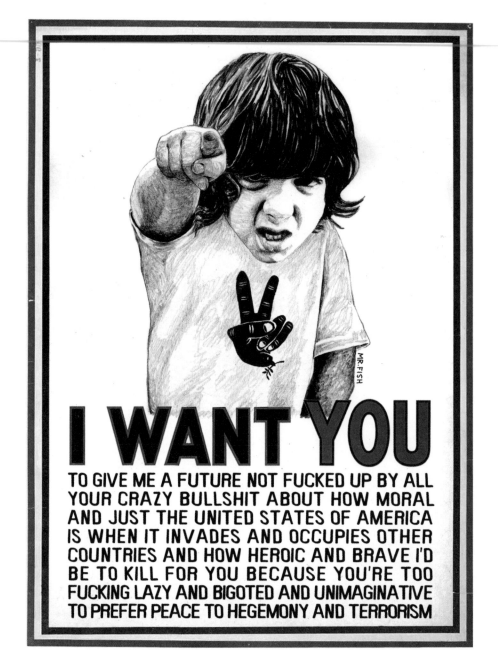

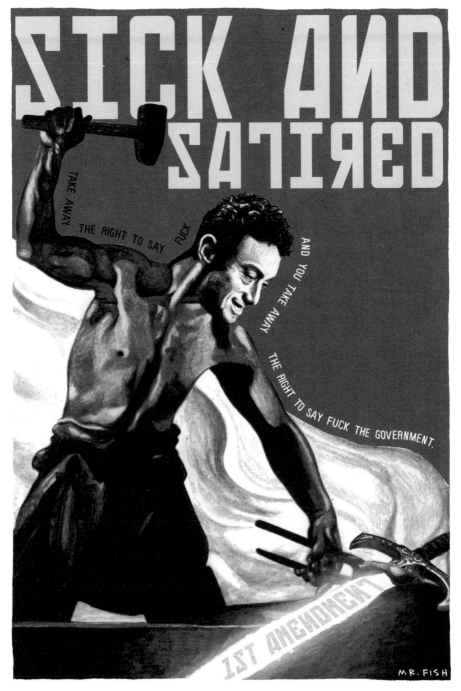

ACTIVISM:

ME WE WE WE WE ME ME ME ME ME ME WE WE WE ME ME ME ME ME ME ME ME ME ME ME WE WE WE WE WE ME ME ME ME ME ME WE WE WE WE WE WE WE WE WE WE ME ME ME WE WE WE WE WE WE WE WE WE WE WE WE ME ME WE WE WE WE WE WE ME WE WE WE ME ME ME ME ME ME ME ME WE WG WE WE WE ME ME ME ME ME ME ME ME ME ME ME ME WE WE WE WE ME ME ME ME ME ME ME ME ME ME ME ME ME ME WE ME

MR.FISH

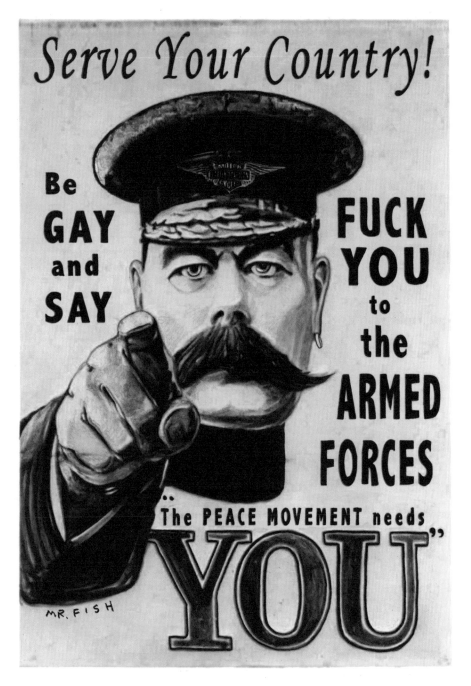

A PILE OF DEAD PALESTINIANS STALLING THE PEACE PROCESS BY
INSENSITIVELY MOCKING THE JEWISH MONOPOLY ON AGONY.

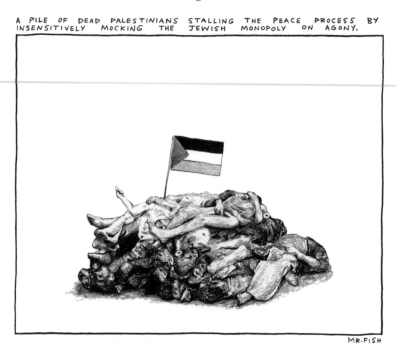

HIPPOCRATES TAKING HIS OATH

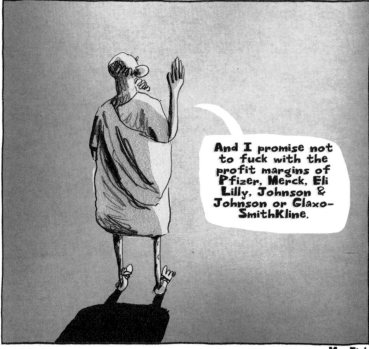

MILITARY TECHNOLOGY FINALLY BECOMING POWERFUL ENOUGH
TO BE TRULY EFFECTIVE.

MR.FISH

ISRAEL ATTEMPTING TO RID THE WORLD OF ANTI-SEMITISM.

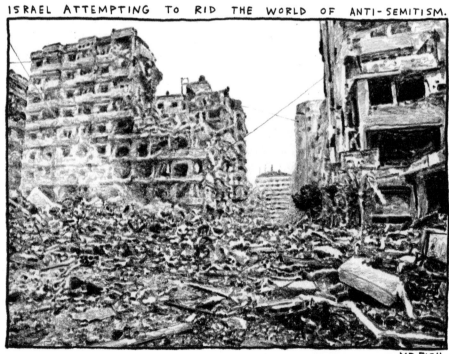

MR.FISH

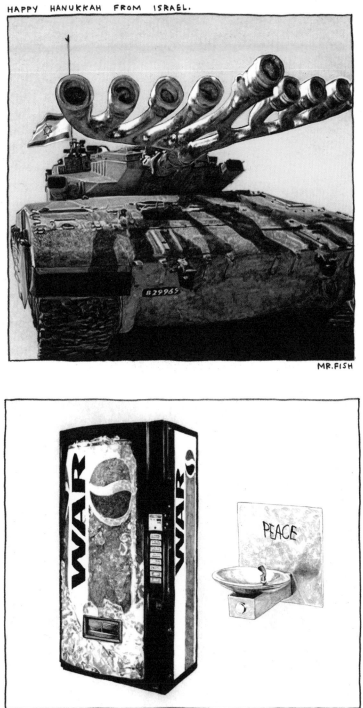

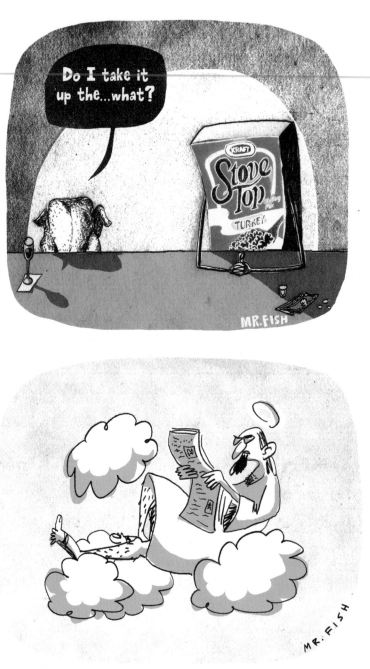

"Aw, shit – not again! Looks like when I had all my attention focused on helping that Little League team in Fairfield, New Jersey, win its first game of the season a whole village was slaughtered with machetes in the Congo, Barack Obama murdered another couple dozen Pakistanis and the Israelis blew the heads off another bunch of 10-year-old Palestinian soccer players just for the fun of it. Sometimes I wonder if there'd be less human suffering in the world if I wasn't such a sports nut."

Mr. Fish

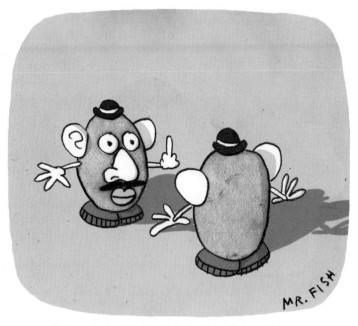

Mr. Potato Head and Mr. Patattah Head not being able to work things out.

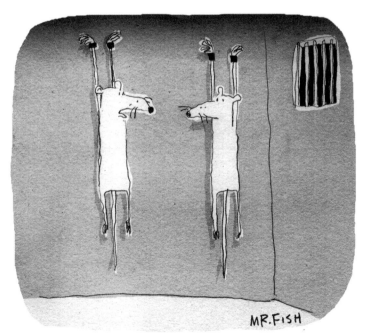

"To be honest with you, it isn't the injections or the sleep deprivation or the waterboarding that disturbs me the most – it's more the relentlessly crazy belief that I somehow know the secret of how to cure cancer."

"People are so worried about what gay marriage will do to the community and the irony is that they probably learned all about what a community is from me and I've had a guy's hand up my ass for the last 40 years."

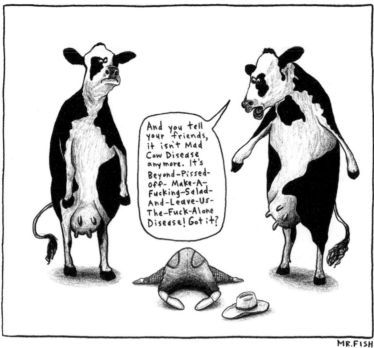

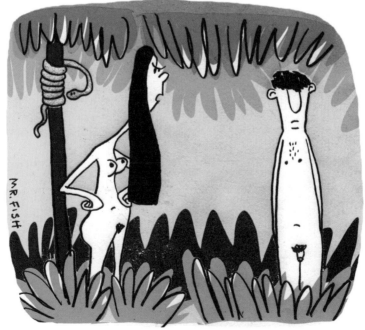

"Well, exactly how many other ribs do you have?!"

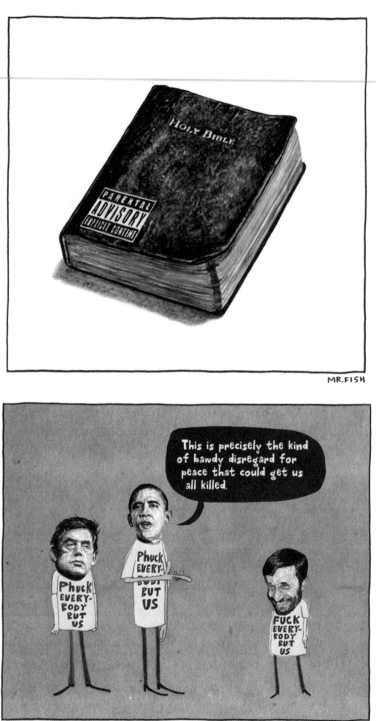

MR. FISH

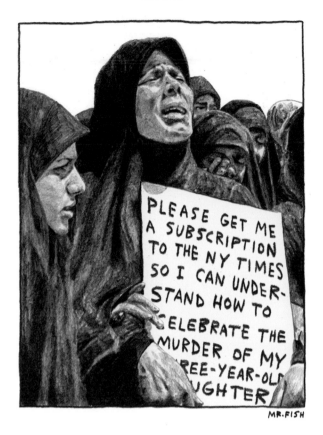

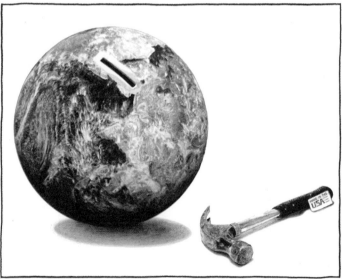

Toto angry at himself for not asking for his neutering to be reversed.

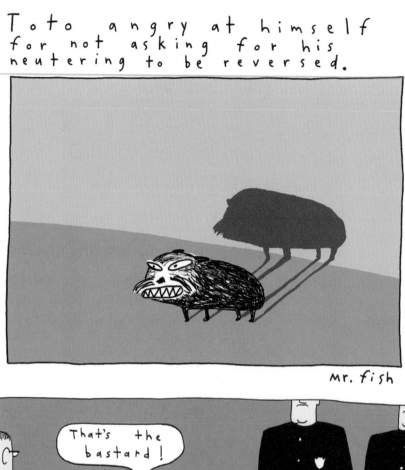

mr. fish

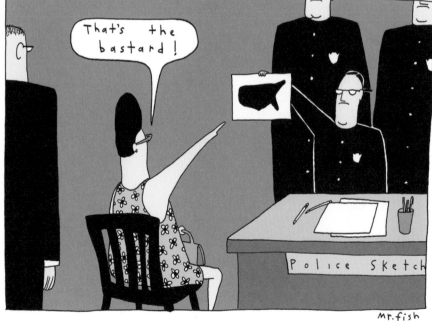

Virginia finding out there's a Santa Claus, but not hearing the answer to her second question about how really fat people go to the bathroom.

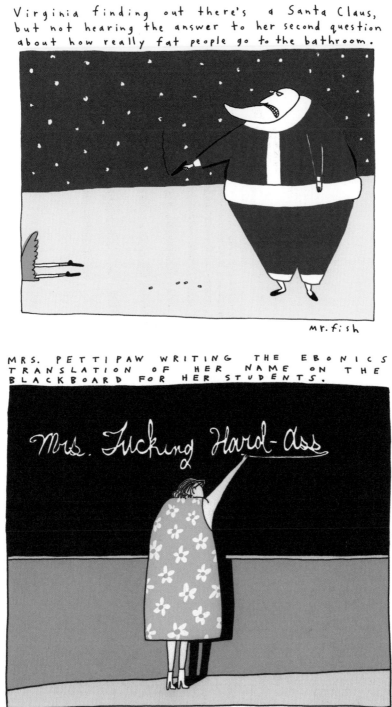

MR. fish

MRS. PETTIPAW WRITING THE EBONICS TRANSLATION OF HER NAME ON THE BLACKBOARD FOR HER STUDENTS.

Mrs. Fucking Hard-Ass

Mr. fish

"What can I say? He called me a pussy so I shot him."

"Hey, bitch, you're standing on my pecker."

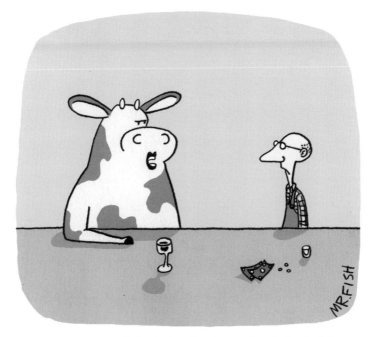

"You want to do WHAT with a tiny stool and a bucket?!"

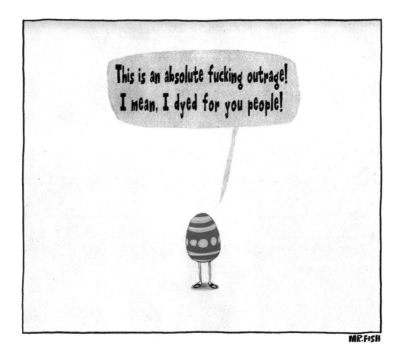

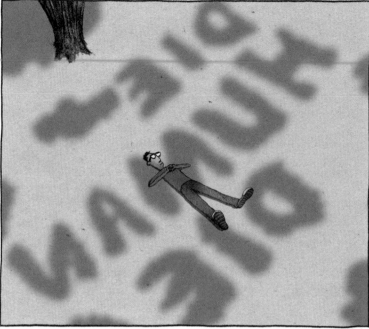

TAKING FURTHER ADVANTAGE OF THE CONGRESSIONAL
RECESS, PRESIDENT BUSH APPOINTS ROBERT BLAKE
TO THE NEW CABINET POSITION OF SECRETARY OF
WHAT-THE-FUCK-ARE-YOU-LOOKING-AT?

NEW VIDEO SURFACING OF INCENDIARY SERMON THAT IS EXPECTED
TO FORCE ALL U.S. PRESIDENTIAL CANDIDATES TO IMMEDIATELY DISASSOCIATE
THEMSELVES FROM ITS SPEAKER AND TO FINALLY DEVELOP A CODE OF
ETHICS THAT IS NOT BASED ON AN ANTIQUATED PHILOSOPHY OF IN-
TOLERANCE AND BULLSHIT-CHURNING VOODOO.

From Matthew 10:34-39. Do not think that I came to bring peace on the earth; I did not come to bring peace, but a sword. For I came to set a man against his father, and a daughter against her mother, and a daughter-in-law against her mother-in-law; and a man's enemies will be the members of his household. He who loves father or mother more than me is not worthy of me; and he who loves son or daughter more than me is not worthy of me.

MR.FISH

MR.FISH

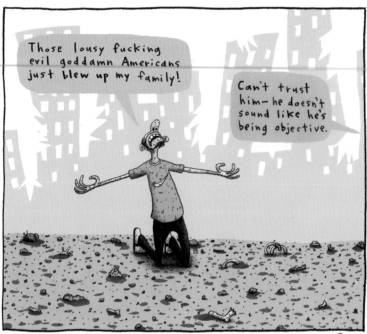

WAR DERIVES FROM THE SUBJECTIVITY OF PEACE

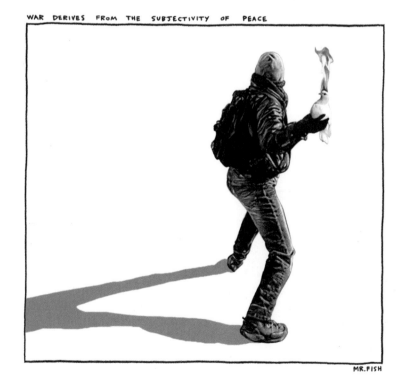

CANDIDATES DEBATING THE ISSUES MOST RELEVANT TO THE SPIRITUAL NEEDS OF THE COMMUNITY.

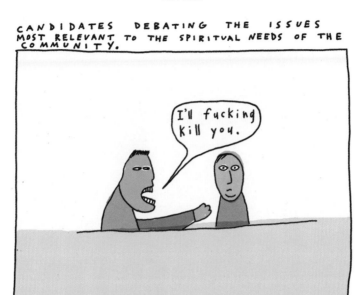

Previously unaware of the power of cartooning to affect world politics, Charlie Brown decides to exercise his newfound significance.

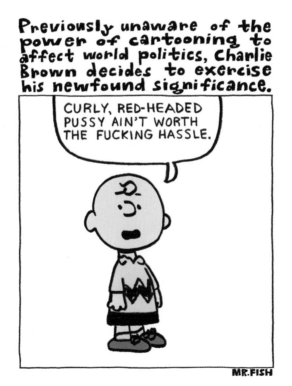

God Fucking Allah.

Allah Fucking God.

MR.FISH

MR.FISH

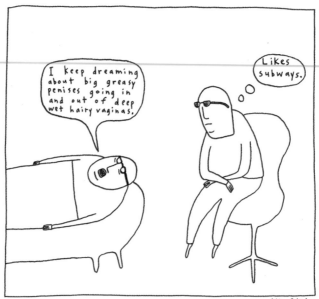

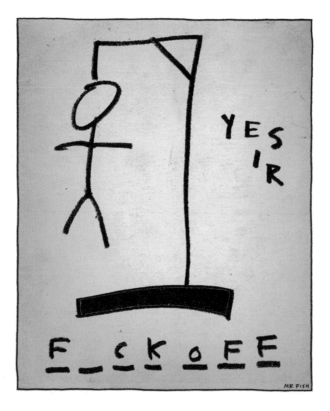

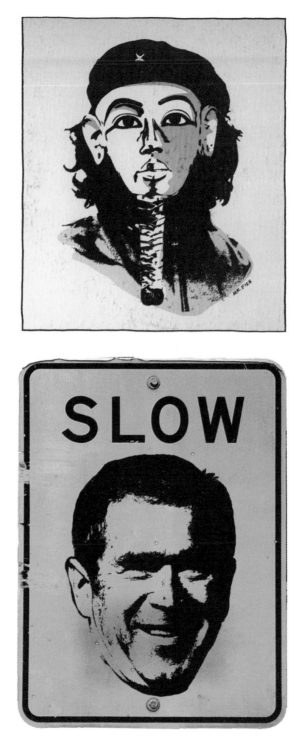

CONDOLEEZZA RICE MEETING WITH LEBANESE PRIME
MINISTER, FOUAD SINIORA, TO INFORM HIM OF HOW
DEEPLY THE UNITED STATES FEELS THE PAIN OF HIS
PEOPLE.

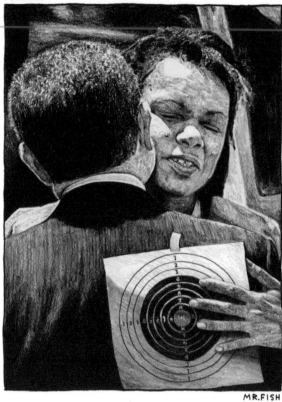

MR.FISH

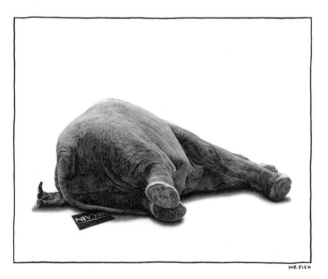

MR.FISH

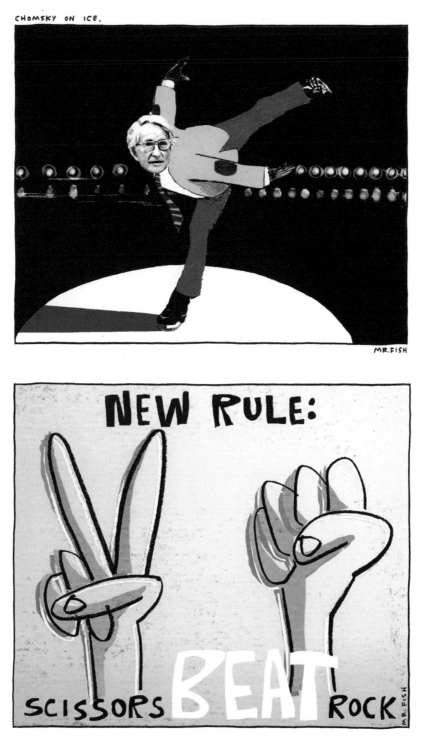

A man is a success if he gets up in the morning and gets to bed at night,
and in between he does what he wants to do.
—Bob Dylan

Denial

K afka was barely a car. In fact, it was closer to
being a lawn mower. The only thing that made
it not a lawn mower was its Volkswagen shape
and the fact that it couldn't cut grass. That, and
rather than smelling of freshly cut lawn clippings
and pulverized dandelions and earth, the
interior smelled like cigarette smoke and
french fries and a wet rug that had been
frozen and thawed and frozen and thawed
and frozen and thawed, over and over again,
for a generation. It was the kind of car
whose corrosion and decay engendered
endearment rather than disgust and, like
an old dog, there was the likelihood that
once it eventually did die everybody would
immediately forget about the stench that
oozed green from its exhaust pipe and the
viscous brown puddles it left whenever it
rested anywhere for more than two minutes,
and only remember its tired enthusiasm to
please everybody.

It was twenty-two degrees outside on the
night before the night before Christmas in
1984 when Darcy Pemberton pulled into the
driveway, Kafka's wheezing guttural enough
to vibrate the water in the fish tank and send
the cat out of the room, and I grabbed my coat
and flew out the front door before my
mother had a chance to walk down the
hallway and plead with me, using only

exquisitely sad eyes and absolute silence
for the billionth time that day, to not

drop out of college. It was the middle of my freshman year at Rutgers University and I already knew that I wanted to get my education outside of a classroom, just like I imagined a fisherman would rather pull a fish from the treacherous depths of his own cunning and guile than from a can—that's what I told her. Then I told her how John Lennon had said, "If there is such a thing as genius, I am one, and if there isn't, I don't care." This made her roll her eyes. Then I told her how Ralph Waldo Emerson had said, "Accept your genius and say what you think." This made her want to throw up. Then, to change the subject, she told me that she still hadn't figured out a name for the new parakeet she'd gotten my stepfather for Christmas, which hadn't stopped screeching like a smoke alarm since it entered the house. After that she left the room, which was when I went into my bedroom and grabbed a piece of blank paper and wrote down what I thought was the perfect name for a bird. I drew an arrow and stuck it up next to screeching birdcage in the darkened dining room and forgot about it.

Darcy wasn't in college yet. She was a year behind me and still a senior at my old high school, and her eagerness to graduate into the awesomeness of the rest of her life was so typical of her age group that I found it impossible to slight her for giving a huge shit about absolutely everything. She had been in my art history class when I was a senior and I remembered thinking when I first saw her that she'd be pretty if she were just a little bit uglier. Really, her looks reminded me of the confused thrill one can get with a new pair of sneakers. On the one hand, there's the loud minty perfection of the things, the public pronouncement that you have attached something unblemished, something *á la mode*, to your character and that, by proxy, there is an excellence and a brilliance about you that is undeniable. New sneakers allow you to stand inside the virgin birth of au courant fashion, making you feel a little bit indestructible. And then, on the other hand, there's the cheap affectation of the things, the feeling that your ruddy humanness, your plain and all too common *animalness*, will never be able to corroborate the promise of invincibility held by your footwear. Pristine, unscuffed sneakers are as likely to cure you of being average as a toupee is to cure you of baldness. That's why dirty sneakers are so much better looking than the new-begotten versions, because the honesty they reflect by mirroring the bruises and scratches on every human soul is deeply reassuring. To celebrate imperfection is to cast a very wide net indeed; to embrace the ordinary is to broadcast loudly and clearly that none of us ever needs to feel alone.

That's why Darcy Pemberton, with her perfect teeth and long straight

hair the color of Honey Smacks® and her obvious disregard for her nipples, which were always as stiff as almonds, forever braless and swinging this way and that, wasn't really *hands-on* pretty until she revealed herself to be a truly magnificent imbecile. It was the equivalent of being intimidated by the vision of the Grand Duchess of Porkshire sitting all alone at the park fountain, her nose in the air, her splendid gown billowing about her like so much butter cream, and then seeing her bend over to lift a squirrel by its tail and lick its ass, one drenching swipe like a German shepherd, before setting it back onto the ground, her ability to intimidate the dispossessed eternally lost. Likewise, overhearing a girl in your high school art history class say to a friend, her head cocked like a teapot set to pour, "If ketchup and mustard *aren't* opposites, then how come peanut butter and jelly are?" is to find out that she probably has no capacity for the sort of critical thinking capable of weeding out white-hot horniness from anything approaching genuine affection.

In fact, rather than even liking Darcy Pemberton a little bit, I found her simplicity infuriating. Besides having a Jersey accent as thick as a wet rope and an absolutely putrid infatuation with unicorns, she was the kind of girl who you had to say you were kidding to after you kidded her, instantaneously making her the kind of girl who you wanted to say you were sorry to after you pushed her out the window and the only thing that stopped you from doing it was not wanting to be polite.

"Where do you want to go?" she asked me, chewing on a hank of her hair like a tomboy and exhaling tiny gray clouds into the freezing cab of Kafka, her woolen hat pulled down nearly to her eyelashes, the circular appliqué patch of a unicorn leaping over a rainbow set at the center of her forehead like a doctor's head mirror.

"Well," I said, closing my door and pausing to blow into my hands and ignore her patch, the open cracks in the upholstery pinching at my backside. "What's open?" I finally asked, looking at my watch and noticing that it was already ten o'clock. She laughed and said that I was funny, making no sense whatsoever, and backed the car into the street and drove us away. "Just not your house," I said, having spent the previous night getting stuck playing Monopoly with her and her little sister while her mother, who looked like a seal that had been bleached and then humiliated with lipstick, polyester, and a cymbal crash right next to her head, sat in the kitchen drinking what looked like gasoline out of a jelly glass and mumbling to a giant parrot cage covered by a torn bedsheet.

Twenty minutes later, and following an eleven-word conversation about what we were planning to do during our winter break, we were sitting at the dark end of a gravel parking lot outside of Historic Smithville with the motor off and the ignition on and country music versions of Christmas songs seeping out of Kafka's tinny radio like methane. Similar to so many other touristy historical towns on the East Coast, Smithville had been built in the middle part of the twentieth century in commemoration of the colonial era, which it promoted as a simpler time when people churned their own butter, spun their own baskets, and threw their own heretics into their own stocks, and when shoppe owners overcharged for cheap tar-paper three-cornered hats, shitty T-shirts, bumper stickers, and goose feathers fitted with the innards of crappy ballpoint pens. *Ye Olde Fucking Rip-Off!* Through some nearby trees we could see a battalion of Red Coats marching across a wooden footbridge lit up with hundreds of little white lights, and I was imagining how many of these guys pretending to be British soldiers were counting their marching as acting experience and putting it on their résumés in the hopes of it helping them get a real acting job, like posing with a bottle of motor oil in a magazine or selling toilet paper to other actors on TV who pretend that their assholes are just screaming for the stuff, when Darcy put her hand on my knee.

The *American Heritage Dictionary of the English Language*, Third Edition, Copyright 1992, defines the penis as: n., 1. *The male organ of copulation in higher vertebrates, homologous with the clitoris. In mammals, it also serves as the male organ of urinary excretion.* Well, I'm here to tell you that this is only half the story. In fact, to qualify the penis as a noun is not entirely accurate. Saying that a penis is a noun is a little bit like saying that laughing at your best friend's mother while you and your best friend's entire family listen to her fall down the cellar steps with an accordion strapped to her chest at a party celebrating her first year of sobriety is a verb; technically it is, but realistically there's a lot more going on to inform your definition of what laughing means. My own experience, not to mention the experience of anybody who's ever come within five feet of one of the things, indicates that it is much more of an adjective that was given the properties of a noun simply to accommodate the practical demands of both urination and procreation—namely, that the only part of speech capable of pissing straight or entering a woman and squirting more than just interjection into her is a noun; that is, just as the words *highfalutin* and *evangelistic* and *cotton-picking* are nouns in physical body upon the paper and adjectives in meaning, so too is the penis, physical upon the body and meaningful only as a modifier of a man's most narcissistic, pleasure-seeking

tendencies, otherwise known in Freudian terminology as his id, defined by the American Institute of Psychiatrics as: n, 1. *Fuck you!* 2. *Fuck me!* 3. *Fuck everybody and every (fucking) thing!* 4. *(Go) Fuck your mama (mother)!* [*See oedipal, wipe your feet, fix your hair, and pull down your CLEAN underpants.*]

That's why when Darcy's hand fell upon my knee, even though I didn't really know her and even though I'd only seen her a handful of times since high school and even though contemplating the intricacies of her personality was a lot like figuring out how a see-through plastic water pistol worked, I suddenly felt as if I'd become substantially less real in the physical sense, less like a *noun*, and more like the ethereal descriptor that provided my *meatiness* with an exhilarating narrative. Her touch made her a lot like Jesus or Vishnu or Kim Jong-il in that way. Sure, it probably had a lot to do with the infamous gullibility of semen and nothing to do with Christmas or any kind of spiritual connection that Darcy and I shared—semen being as easy to get out of a teenager as ketchup is to get out of a bottle that's being turned upside down and squeezed—but, still, it was thrilling to suddenly feel as if the evening, while perhaps not blessed with a purpose, at least had some new expectation that it would end with the icky crescendo that, truth be told, I was praying for but not banking on. After all, just as one's biological need to eat is programmed into one's pleasure center in order to avoid becoming a bodily function with very little chance of repeating itself day in and day out because it is a monotonous drudgery incapable of being sustained through a lifetime, one's biological need to engage in at least one's half of the reproductive act is similarly hardwired into one's appetite for joy, for without joy fucking would be gruntwork, the sort that may easily be postponed indefinitely. And then there'd be no me and no Darcy Pemberton.

And no Historic Smithville, New Jersey. And no body heat to fog up Kafka's windows sufficiently to provide me and this dolt of a high school senior with all the privacy of being trapped inside the crud of our own lurid imaginations. And no way to make the night end regrettably, with the predictable collapse of noble Christian decency and Victorian restraint.

"Hey, Dwayne," she said, her hand still on my knee.

"Yeah?"

"What would you do if God came to you late at night and asked you to murder your son by stabbing him on the top of a mountain?"

Huh?

"What do you mean," I asked, "like in the Bible story?" I looked at her in the dim light and then remembered the unicorn patch and turned away.

183

"Yeah, the story of Isaac."

"I'd pretend I was asleep," I said.

"What if he saw your eyelids move?"

"I'd pretend the knife drawer was stuck while my wife called the police on the neighbor's phone." I leaned back and untucked my shirt. She took her hand off my knee, buttons and zippers and clasps requiring the coordinated cooperation of a right- and left-handed set of fingers, I prayed.

"I'd probably kill myself and my son," she said.

"You're going to make a wonderful mother one day." I watched as her hands searched her coat pockets. *Condom? Ecstasy? Sundae toppings?*

"And if he had any other brothers or sisters, I'd probably kill them too. I couldn't live with the, what do you call it, separation anxiety."

"Let's hope none of them ever wants to go away to camp or wears a shirt that makes them blend in with the sofa," I said, wanting her to shut up.

"Would you go with your dad if he woke you up and said he needed to disembowel you on top of a mountain because God said so?" she asked, taking out a ChapStick and applying cherry-scented petrolatum to her lips.

"I don't know who my real dad is," I said. Feigning innocent exhaustion, I reclined my seat and yawned, stretching my hands over my head and allowing the crescent of skin just above my belt buckle to show.

"How about your stepdad?" she asked, offering me the uncapped Chap-Stick.

"I'd be surprised if God asked my stepdad to do anything for him," I answered, taking the lipstick and circling it around the O of my lips. "My mother's been asking my stepdad to reset the seal on the toilet for a year now and the closest he's actually come to doing it is suggesting that we all poop at the gas station and only flush the home toilet once a day."

Again, she rested her hand on my knee. "You're funny."

"Hilarious," I said, wishing that she would turn the fucking page already.

"So are you really going to drop out of school?"

"Aw, Jesus," I sighed, covering my face with my hands.

"You seriously shouldn't," she said, now rubbing my leg, "because you're a really good artist."

"What's that got to do with college?"

"Don't you want that piece of paper?"

"What piece of paper?"

"A diploma."

"It's just a fucking piece of paper," I said. "You sound like my mother."

"I'm just saying that the stuff you had in the art show last year was pretty frigging amazing—you could work at an advertising agency, I swear!" She took her hand off my knee so that she could recline her own seat and then shift to lay on her side. "Plus, I heard you got an art scholarship to go to Rutgers, and not everybody gets a scholarship."

"I got $250 from the Pine Shores Art Association. Big fucking deal!"

"It's still a scholarship," she said, naming the image of the rolled-and-ribboned parchment paper she had in her pea brain and making absolutely no point.

"After they sent me the goddamn check, they asked me to come to a banquet and address their members, so I did. And when I showed them my drawing of John F. Kennedy's head being exploded by a golf ball, everybody just stared. It's all bullshit." I sat up and straightened out my seat. "They only give scholarships to assholes who they think aren't going to embarrass the foundation that gave them the money!" She didn't say anything. "You don't hand somebody a check and then tell them to go draw a picture of Ronald Reagan saluting the flag and jerking off at the same time!"

"Did you do that?"

"Yes! And stuff that's even *better* than that!"

"Wow," she said, turning onto her back and stretching to reveal the crescent of skin just above her belt buckle.

"Yeah, I just started doing political cartoons too, but I have to come up with a pen name because there's already a *Booth* who does crap for the *New Yorker*. My shit is way better than the *New Yorker* dude, though."

"Hmmm," she said, folding her hands under her head and elevating her bosom.

"Do you want to see it?" I asked.

"Do I want to see what?" she replied, her words as diaphanous as lace.

"My portfolio from college. I have it back at the house."

"At your house?"

"Yeah."

"*Now?*"

"Yeah," I said. "It's fucking freezing out here, anyway. I'll make some tea and light a fire and show you my stuff."

"You want me to come back to your place so you can show me your *etchings*?" she said, grinning.

"Yeah, but they're not etchings, they're drawings." I leaned forward to wipe a portal onto the windshield for her to look out of with the sleeve of

my coat, my chivalry absolutely dripping with goatish virility. "Nobody will bother us, my parents will be asleep—it'll be fun." I sat back and dried my arm on my pants.

After reaching down to release her seat, which sprang up behind her like a catapult, she bent forward and caught me off guard and kissed me deeply on the mouth, her lips as warm and sloppy as live bait. Then she turned the key in the ignition and machine-gunned the outside air with a sound like eighteenth-century musket pellets blasting through a twentieth-century garbage can and we were gone, the nighttime suddenly as bright and promising as a peppermint stick.

Sitting alone at my art table the next morning with blurry eyes and hair that looked as if it had been sketched onto my head by somebody attempting to scribble out my brain, I looked up to see the sign containing the name *Mr. Fish* that I'd made for my stepfather's new bird the night before. It was taped to the wall, having been rejected by my mother, its arrow pointing at the empty sketchbook before me. I shrugged and thought about how Darcy Pemberton had looked just hours earlier, there in front of my fireplace in her socks and T-shirt, and how quiet she was as I flipped slowly through my portfolio and tweezered meticulously—like picking very little nits off a very big monkey—at the meaning of each of the 133 drawings I'd done since becoming a disgruntled college freshman. I imagined how deeply my genius must've penetrated through the glistening folds of her cerebral cortex and how good it must've felt for her to have her insides stretched beyond capacity by my brilliance, her awed silence like that of somebody looking upon the Grand Canyon for the very first time, never having gazed into such a gigantic hole before.

I swore to myself that I'd never forget the appreciation that I felt in her handshake when she left, too distracted to make another date with me, the great herds of unicorns having been driven from her worldview and replaced with my unmistakable, dare I say superhuman, clarity of vision.

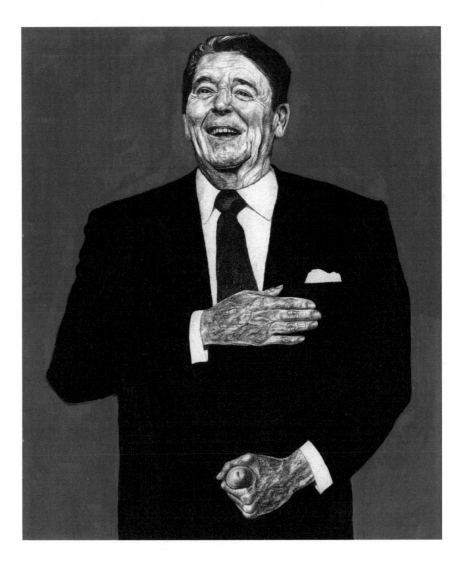

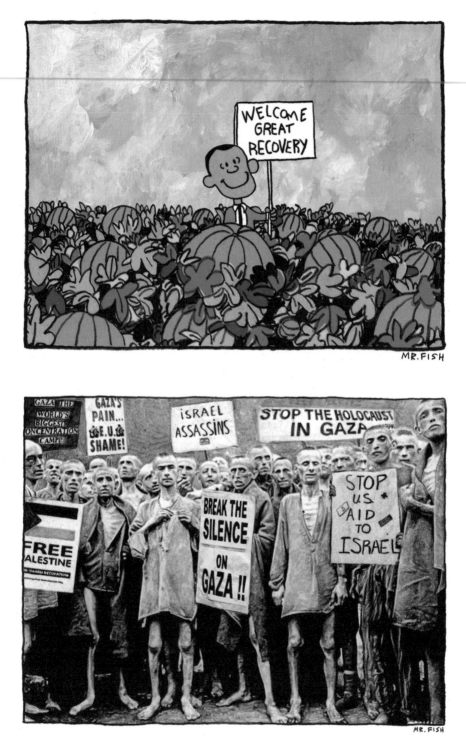

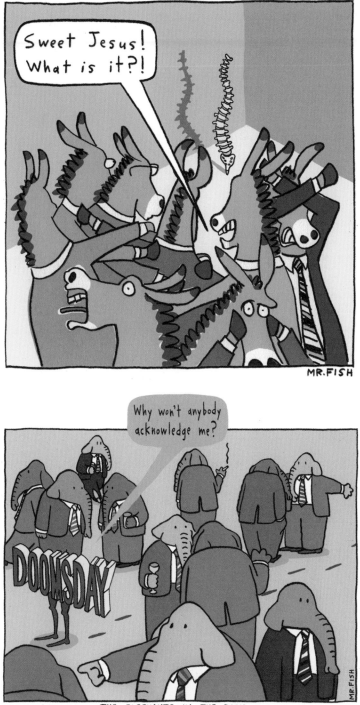

THE ELEPHANTS IN THE ROOM.

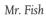

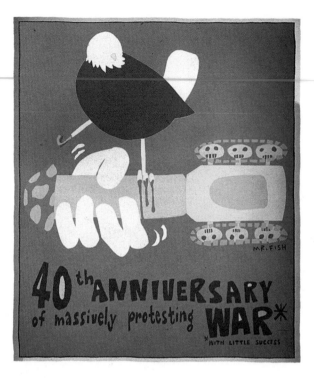

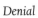

21st Century Saint

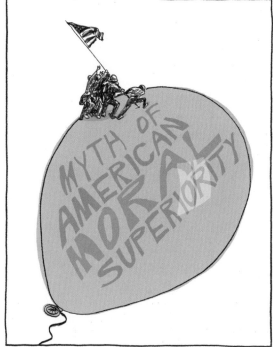

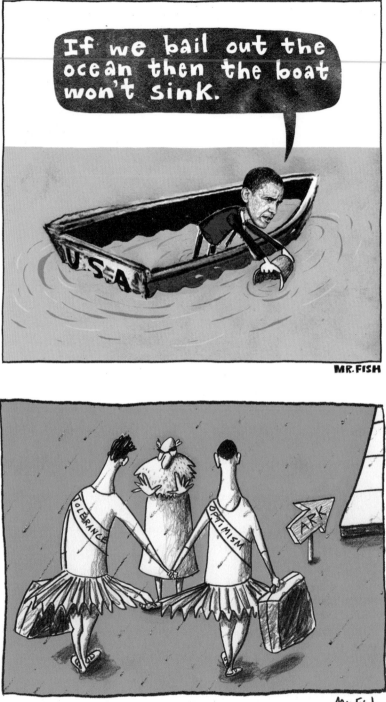

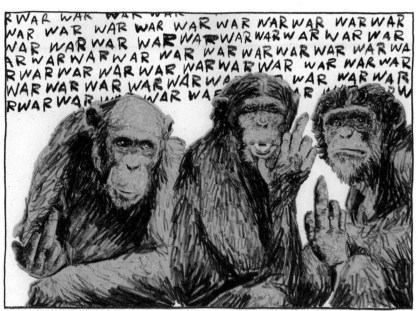

MR.FISH

REPUBLICANS AND DEMOCRATS GETTING TOGETHER TO DISCUSS WHY THE MIDDLE EAST SEEMS SUSPICIOUS OF THE AMERICAN CONCEPT OF DEMOCRACY.

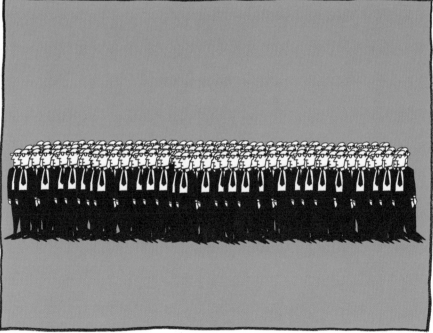

MR.FISH

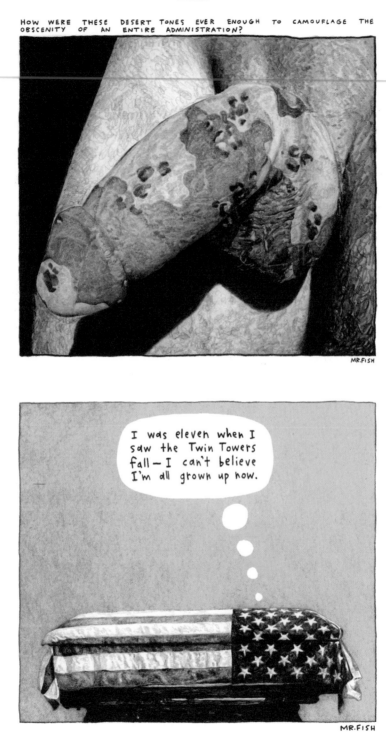

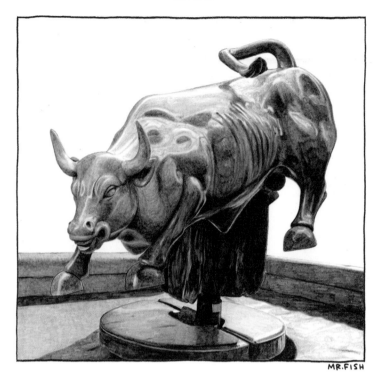

BARACK OBAMA STEAMING HIS WAY THROUGH AFGHANISTAN TOWARDS OSLO TO PICK UP HIS NOBEL PEACE PRIZE.

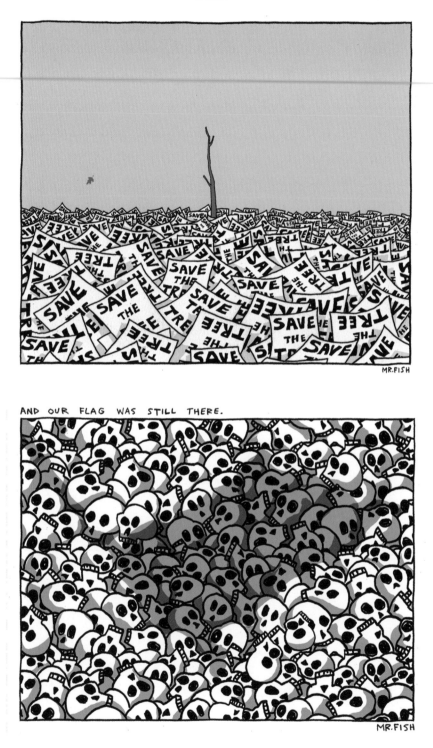

TREE OF KNOWLEDGE.

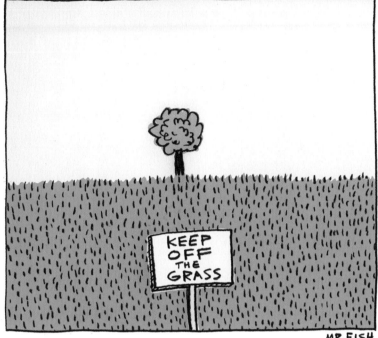

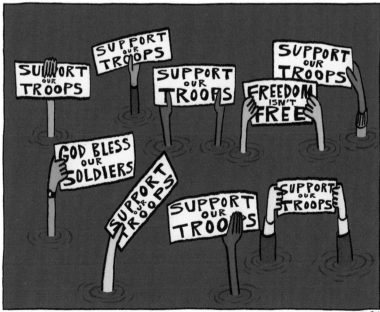

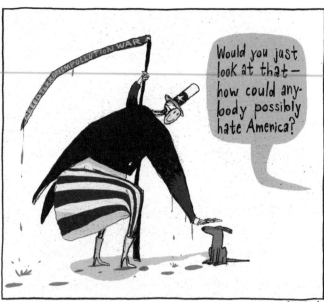

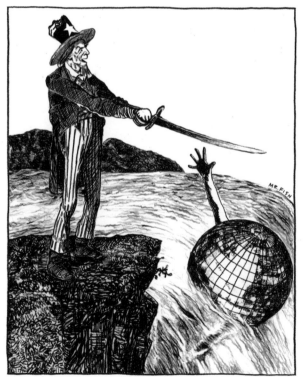

"Grab it! I'll save you!"

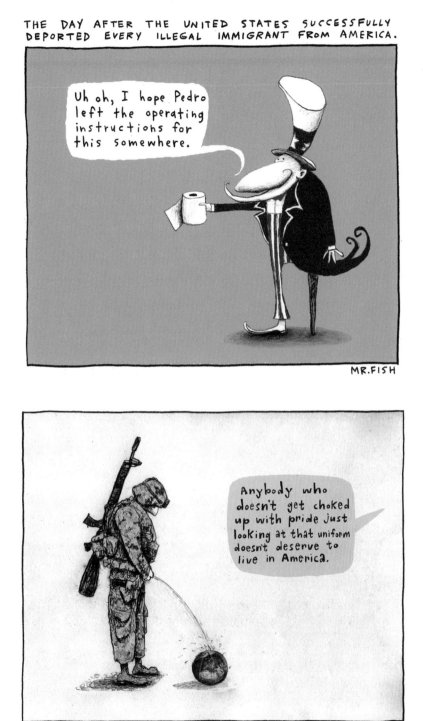

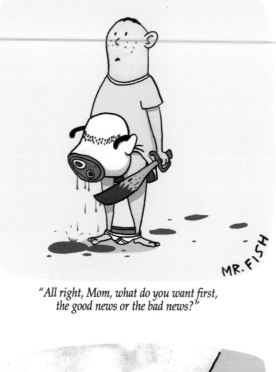

*"All right, Mom, what do you want first,
the good news or the bad news?"*

"Mom?"

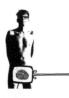

"Rudolph? Aren't you glad that we're nothing like the
lousy goddamn niggers?"

"Well, him saying that he's a vegetarian doesn't necessarily mean he's the sensitive type."

"Oh, silly me! It wasn't a blow job, after all."

MEMORIAL DAY, 2010

Billy learning from the **Woodstock Generation** how to spread democracy, preach peace, save the world and make life beautiful.

"Sorry, baby, not tonight – I gotta rise up early tomorrow."

"I remember hearing something, but I just thought somebody was hanging a picture."

Royce Nib fretting over the demise of the newspaper industry.

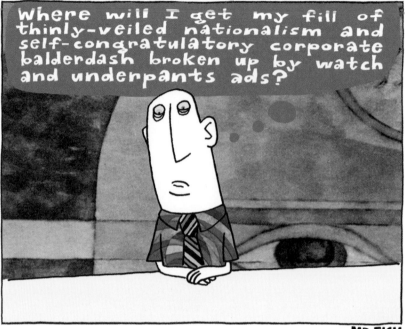

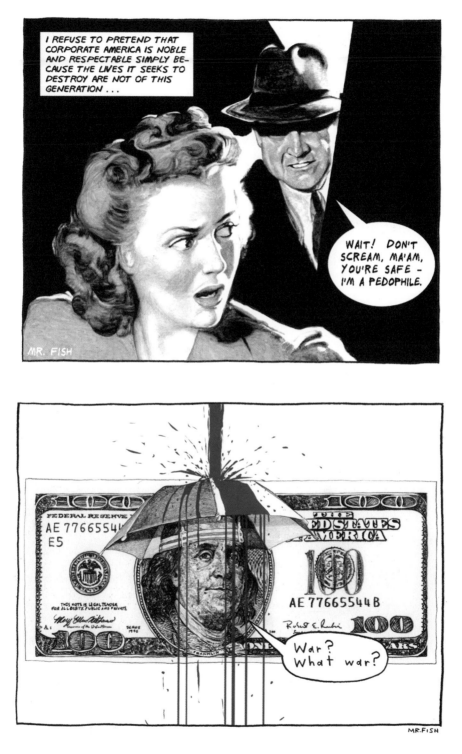

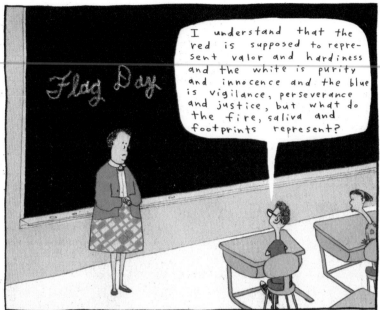

ALEX FINDING OUT THAT HIS OTHERWISE LIBERAL PARENTS MIGHT HAVE A PREJUDICE AGAINST FOREIGN PEOPLE.

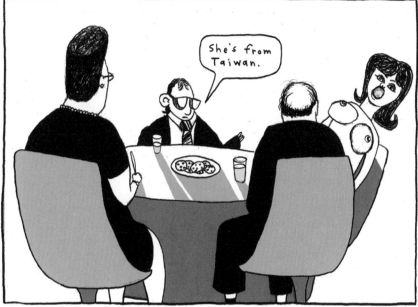

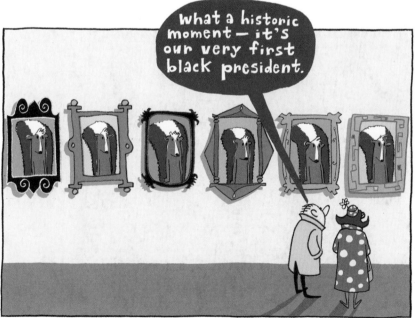

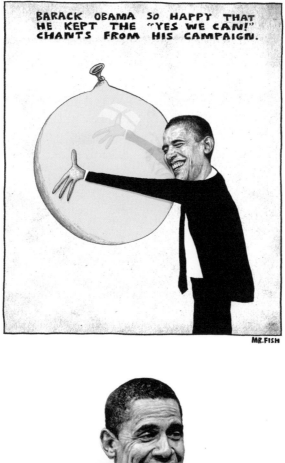

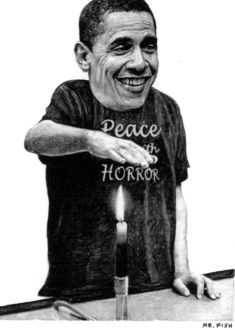

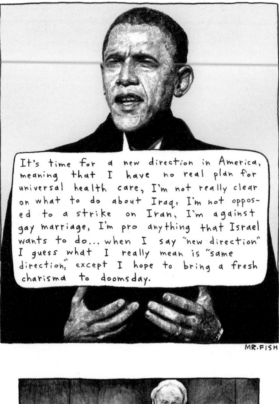

It's time for a new direction in America, meaning that I have no real plan for universal health care, I'm not really clear on what to do about Iraq, I'm not opposed to a strike on Iran, I'm against gay marriage, I'm pro anything that Israel wants to do... when I say "new direction" I guess what I really mean is "same direction," except I hope to bring a fresh charisma to doomsday.

MR. FISH

MR. FISH

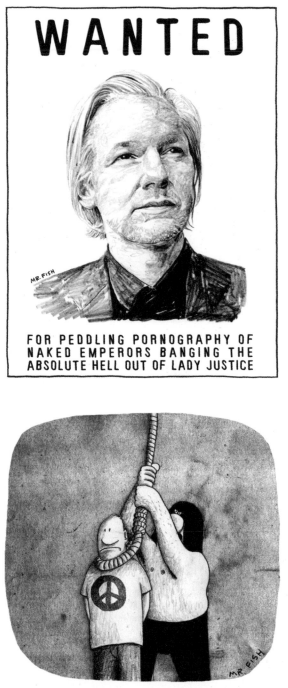

*"They should've known by the warning signs — the high SAT scores, the
late night IT courses, the disdain for government secrecy — that you'd
grow to be a real scumbag."*

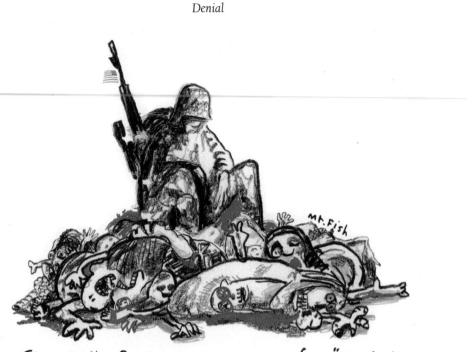

The 21st Century version of "women and children first."

THE VETERAN

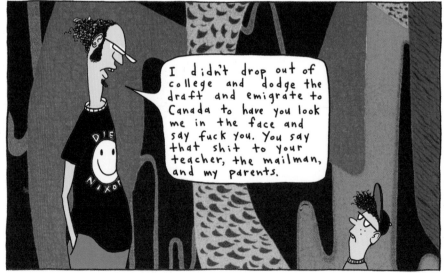

I didn't drop out of college and dodge the draft and emigrate to Canada to have you look me in the face and say fuck you. You say that shit to your teacher, the mailman, and my parents.

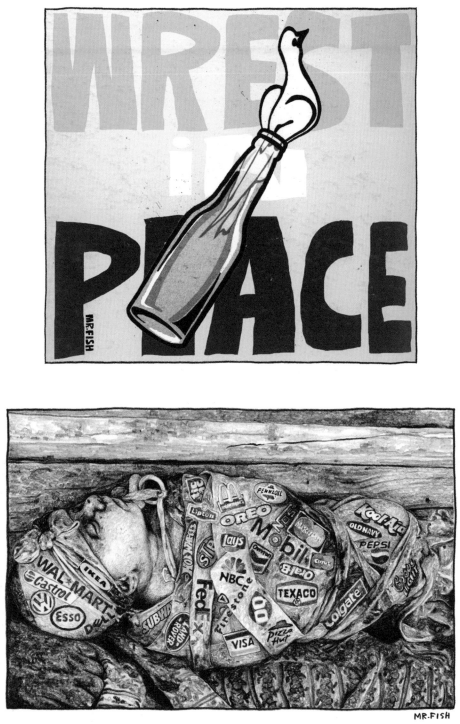

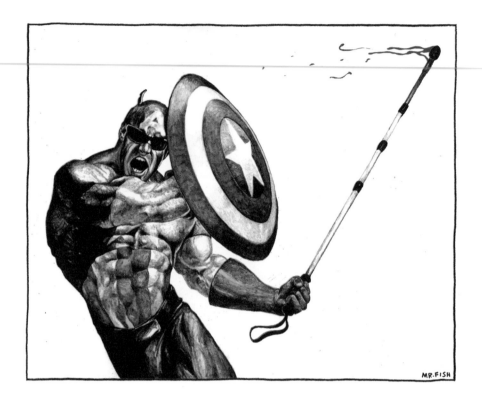

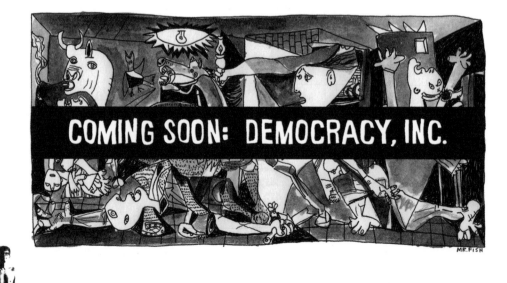

APPENDIX

Why I am not a cartoonist.

MR. FISH

Editorial cartooning has never had a Mozart, much less a Bob Dylan, although there have always been a shitload of Donovans in the profession. *Always.* While the best cartoonists might be able to, on occasion, press themselves up against the high ceiling of creative expression, none have been able to go beyond that ceiling into the diseased and limitless sky where real artistic relevance resides, indefinable and eerily divine, porcupined with existential boners of both elite and lowbrow curiosities and pocked heavily with heartbreaking vulnerabilities, all the while oozing with a charitable self-absorption that is as tenuous and indestructible as light itself. By ignoring the stylistic boundaries that are self-imposed through the cartoonist's commitment to branding and avoiding literal associations with

any specific political or social agenda, a piece of art will prostrate itself to an infinite number of interpretations and, as such, an infinite number of uses by an infinite number of people. Conversely, an editorial cartoonist is only successful if he can get the number of viable interpretations of his work down below two, and he is only expected to express opinions about other people's problems, never his own, which is more in line with the responsibilities of a mother-in-law or Jiminy Cricket than with an artist hoping to starve to death on his own integrity.

Editorial cartoonists, therefore, do not practice art as much as they practice journalism, and as journalists they are, at least the most successful ones, nothing more than polite hecklers of despicable men whose faults are glaring enough to serve journalism's shorthand; that is, whose faults are so obvious that they provide a point of fact that allows the raison d'être of the cartoon to make sense to as many people as possible. (Example: what makes George W. Bush the most lampooned U.S. president in history, surpassing all twentieth-century presidents combined, is the fact that you don't need a house of mirrors to confirm that he is a complete asshole from every angle.) In that way, an editorial cartoonist sheds no new light on a subject, but rather relies on the manipulation of preexisting prejudices to gently cajole his fans into to agreeing with themselves. He is a jingle writer for the op-ed page with his commentary usually fitting as comfortably into the impartiality of his readers as the "Oscar Mayer Wiener Song." Paid by advertisers who provide his publication's income, it is his job to package and sell cultural criticism in a way that is fun! and completely nonnutritious, helping the country to remain so deliciously democracy-flavored while the First Amendment remains untouched like a musket over the hearth of our national identity, too precious to ever fire, all the marksmen of such a weapon long dead, their limbs and vocal cords murdered into coins and statues and lore.

And when I compare myself with all the cartoonists whose work I so frequently and tempestuously abhor, I realize that what I do, while perhaps stylistically more adventurous than others, is not substantively different than the profession's most common toilers. I guess that the outstanding difference between me and other cartoonists, at least the ones I've spoken with or whose personal stories I've read about, is that they all respected the field of editorial cartooning enough to want to be a part of it, citing Herblock and Bill Mauldin and Paul Conrad as their biggest influences; while none of my primary influences were ever cartoonists—they were Friedrich Nietzsche, Woody Allen, Noam Chomsky, John Lennon, Jack Benny, Bugs

Bunny, Voltaire, Benjamin Braddock, and all the dogs my family had while I was growing up. In fact, cartooning for me is the equivalent of waitressing until my true gifts are able to earn me some serious dough, enough to allow me to lay down my cartooning pen forever and ever. My gifts? Well, right now I have two that are pretty much running neck and neck: writing unpublishable diatribes on what's wrong with everything and everybody in the world, and *re*writing unpublishable diatribes on what's wrong with everything and everybody in the world. I, like every other writer or musician or painter I've ever hung out with, am a hamster in a wheel motivated by the smell of his own ass. Like excessive masturbation, some part of me believes that the repetitive nature of writing and rewriting will eventually magnetize my intellect and make it so that other intellects will be inexorably drawn to what I do. I'm hoping that one day my brain will be charged sufficiently to fuck up clocks when I walk down the street and pull the pacemakers out of the chests of ailing poets and yank the chains from the necks of dogs straining to run, to crap anywhere and hump like, well, dogs.

I sometimes wonder if it isn't my job to break people's hearts so severely with the *fuck you* animus of my work that, in the process of putting themselves back together again, they may inadvertently include some of my jokes and ideas as the sinew and cartilage that enable them to reason at all gracefully when facing down the clumsy barbarity of the culture that they may or may not realize they're constantly steeling themselves against.

An argument could be made that the repetitiveness of my writing and rewriting is no more admirable than the repetitiveness that allows many editorial cartoonists to stay in business completely independent of how good or bad their work may be, that repetitiveness being daily syndication. Seen every day, many cartoonists inevitably become like family members to some readers, and like real family members, it may take them decades to say or do anything worth repeating to somebody unrelated. While Gary Trudeau might've earned the moniker of *great innovator* for bringing politics to the comic strip format, he hasn't had anything to say for thirty years—yet I'm sure that if I saw the car he drives I'd think he's still culturally viable. He's not, and he's in 1,400 newspapers. His notoriety simply comes from being a brand name that people recognize, no more imperative to the national debate on politics than a thirty-year-old Rubik's Cube.

Then, along with the repetitiveness of the artwork, often comes through daily bombardment the bogus reinforcement of the cartoonist's occupational reputation as a dangerous character, the type of outlaw who tears truth a

new asshole every time he sets pen to paper, his actual abilities of no importance whatsoever to the equation. Example? Two words: Ted Rall, purported to be the most dangerous progressive cartoonist working today—which he is, if the furthest you're willing to lean to the left is George McGovern. I'd qualify Rall's dangerousness this way: the flabbiness of his vaguely liberal commentary only contributes to the guarantee that the general public won't recognize real radical humor when or if it ever again appears in the culture. It's like conditioning people to define *irreverence* as being what prop comedian and all around goofball Gallagher does when he uses a sledgehammer to splatter his audience with the guts of a watermelon, so that if somebody like Lenny Bruce ever comes along and uses an analogy to splatter his audience with the metaphorical guts of some exploded societal myth, nobody will know how to react, the definition of irreverence having been hijacked and outfitted with speed bumps and *No Spitting* signs. And, of course, a laugh track.

(And speaking of being unfairly labeled with the reputation of "dangerous cartoonist," I have to say that Paul Conrad's infamous inclusion on Nixon's enemies list—something that I hear about ad nauseam—loses some of its prestige when one looks at a few of the other people on the list with him, particularly those closer to the top; people like Carol Channing, Bill Cosby, and, news to me, the Che Guevara of the Hollywood subelite, Tony Randall. Suddenly, the list becomes what it really was: the work of a complete imbecile whose opinion of who was naughty and who was nice shouldn't merit anything but embarrassment and pity. Being proud of appearing on such a list is not unlike being proud that your neighbor's retarded uncle calls you *Mr. Bahd Mahn Poh-Poh Pants!* every morning when you step outside to pick up the paper.)

Now, lest anybody think that I dislike all other political cartoonists or that I think their work is substandard and not worth looking at, the opposite is true. These cartoonists are important merely because they help to remind people that politics are not so complicated that every Tom, Dick, and Harriet shouldn't have an opinion about them. They should. Editorial cartoons help prevent the authoritarian powerbrokers of society from completely suffocating democracy with the bogus idea that only professional politicians and high-powered businessmen should be allowed to engage in the public debate about how government can function. I just want to point out that when it comes to an editorial cartoonist speaking truth to power and championing the causes of the downtrodden and the politically shat-upon, Tom Tomor-

row or Michael Ramirez or Jeff Danziger or Mike Luckovich or Tom Toles are by no means the best out there. No editorial cartoonist is. In fact, they are often decades, even centuries, behind a long line of writers and painters and sculptors and musicians whose ruminations on life better exemplify what deep and thoroughly engrossing commentary should really look like at its most insightful and profound.

Specifically, when one considers the work of people like Mark Twain, Susan Sontag, Honoré Daumier, Frederick Douglass, Dorothy Day, Pablo Picasso, Oscar Wilde, Allen Ginsberg, Diane Arbus, Karl Marx, Louis Armstrong, Henry Miller, Simone de Beauvoir, T.S. Eliot, Francisco Goya, William Shakespeare, Jack Kerouac, Aristotle, and on and on and on, the qualification of any editorial cartoonist as being something even approaching a genius of creative expression or radical behavior becomes problematic at best, outrageous at least. The occupation of cartoonist is too narrowly defined to contain within it something so vast as the concept of *genius*, the same way that a tournament-level nose picker will never compete in the Olympic Games, no matter how good he or she is.

Drawing on the definition I started with, the one about editorial cartoonists being more like journalists than artists, it might be informative to think of them, all of them, as the print equivalent of broadcast journalists, with somebody like the late Paul Conrad being the equivalent of Walter Cronkite. His longevity was obvious, his work ethic was ridiculously Catholic, his likability immense, but one should not be afraid to ask if Walter Cronkite was a journalist whose gifts justify his legend—or if his notoriety stems largely from the celebrity of his celebrity?

In other words, just because history cast him as the journalist who we most often recognized seated at the table closest to the action unfolding on our national stage, and just because his was the voice that we were conditioned to hear as the most reliable when it came to telling us what was going on and why, there's no reason I see to believe—particularly after reading the words of real newsmen like Bill Moyers and Robert Fisk and Robert Scheer and Tariq Ali and Seymour Hersh and Lewis Lapham and Chris Hedges— that the person seated closest to the action is the one with the clearest view. Typically, he's the last to know where the exits are and, sadly, the last one the coroner identifies after a fire suddenly sweeps through from the back of the room where the riffraff and well-to-do congregate to smoke and bullshit and assimilate their humanity.

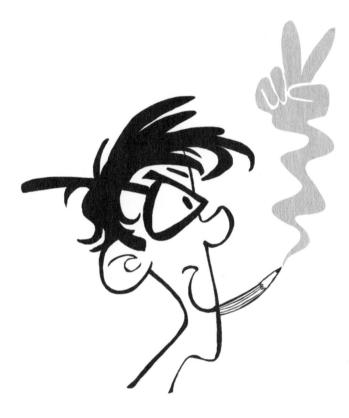